Contents

I Introduction 9

II The photographs 33
1 Alaska 35
2 The Yosemite Valley 45
3 The Modoc War 51
4 Central America 61
5 Palo Alto 81
6 Other travels 95
7 Work at Pennsylvania University: Animals and people in action 113
8 The zoopraxiscope 138

III Appendices 145
Bibliography 155

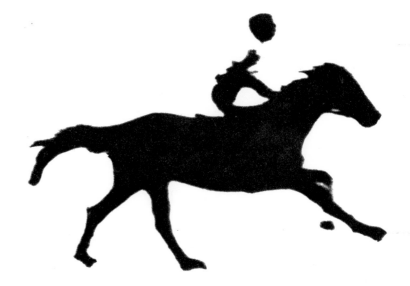

Eadweard Muybridge
The man who invented the moving picture

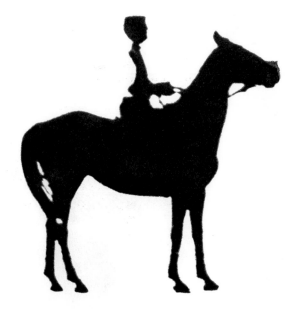

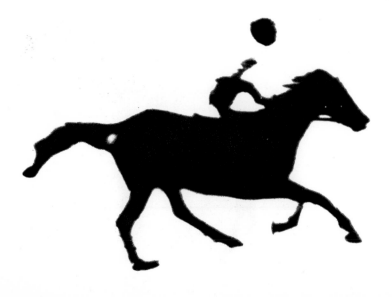

Kevin MacDonnell

Eadweard Muybridge
The man who invented
the moving picture

Weidenfeld and Nicolson
5 Winsley Street London W1

Designed by Nicholas Jenkins
for George Weidenfeld and Nicolson,
5 Winsley Street, London W1

ISBN 0 297 99538 3

This book is dedicated to the pioneers of photography, whose wonder at the way in which light can create a picture never ceased, and whose greatest happiness lay in discovering some new application of the miracle.

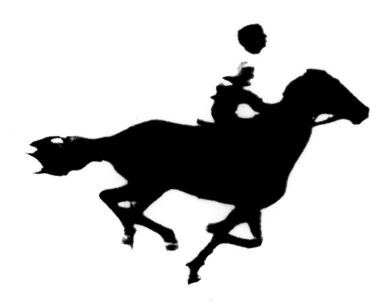

I Introduction

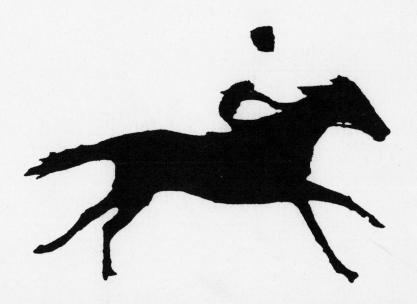

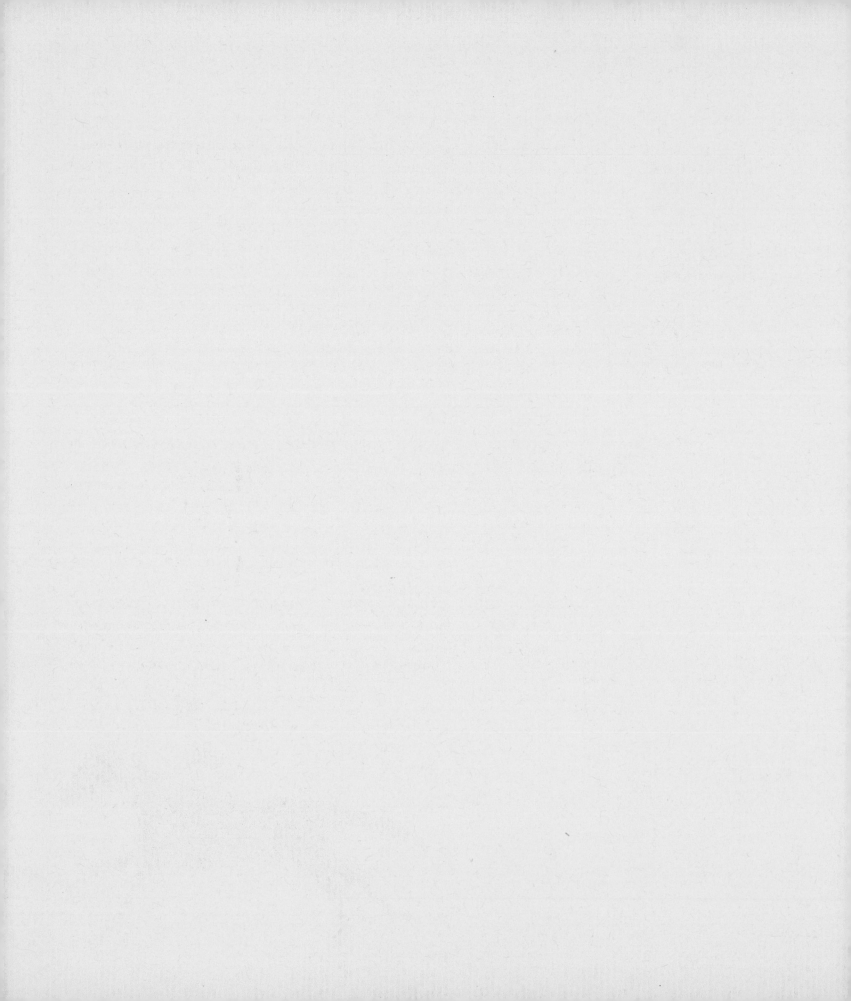

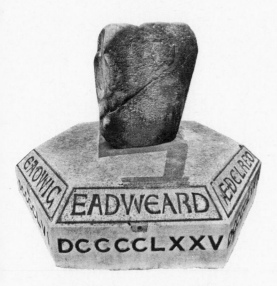

The Coronation Stone at Kingston-on-Thames

The house at Kingston where Muybridge was born

On 9 April 1830, a son was born to John Muggeridge, a cornchandler from Kingston-on-Thames, who lived with his wife Susannah in a narrow, winding lane called The Bittoms. They named him Edward James.

Like most small English market towns, Kingston was a peaceful place, the main excitement being caused by the stagecoaches with names like *The Rocket*, *The Red Rover* and *The Star of Brunswick*, which rattled over the bridge at all hours of the day and night taking passengers from London to Hampshire and West Sussex at an average speed of 9 mph. The railway age had not yet arrived to kill the business and over forty coaches a day passed through the town. Otherwise, very little happened.

Kingston, however, had a great and exciting past, for many of the Saxon kings had lived and been crowned there. Local tradition (there is no historical proof) said that the cornchandler's house stood on the site of the former palace and young Edward, who received a sound education, grew up with a strong interest in local history. This came to a head when, in 1850, the Coronation Stone was moved into the Market Place, accompanied by much Masonic ceremony. On the plinth were carved the names of the Saxon kings who had been crowned on the stone, amongst them Eadweard the Elder, crowned in the year 900 and Eadweard the Martyr in 975. This spelling seemed a lot more romantic than plain Edward so the young man decided to adopt the Saxon version and for good measure changed his East-Anglian surname of Muggeridge, which came from the Norse Mod-Rydd, to Muybridge. The only reason for this change of name seems to have been sheer romanticism.

News of the Californian Gold Rush of 1849 had spread through England and in 1852, under his new name, the young man sailed for America. No definite reason has been found for his emigration, but possibly the thought of spending the rest of his life as a cornchandler was reason enough for anyone blessed with his quite extraordinary mixture of energy and curiosity. He certainly had no dislike for the town itself, for in later life he always stayed in Kingston when he visited England and finally he retired there to die. Into the seventy-four years before this happened, however, he packed a series of almost incredible experiences that make him a unique figure in the history of photography.

Little is known about his early days in the States. He is said to have 'at first adopted a commercial career' but what it was is not clear. In 1860, however, he was involved in a stagecoach accident and was so badly injured that he returned to England where he stayed under medical care for some years. Judging by the way in which he worked for the rest of his life, he must have made a complete recovery physically, but it has been suggested that his accident was responsible for the reputation he later acquired for

eccentricity. In fairness, however, it was probably difficult for anyone earning his living with a camera in the West at the time to avoid such a reputation.

Some time before 1867 he studied photography under Carleton E. Watson of San Francisco and became a master of the wet collodion process, invented by Scott Archer in England in 1851. Watson specialized in pictures of the Yosemite Valley which were huge (22 × 28 inches) but, according to a local paper, inartistic. However, they attracted a great deal of attention when shown at the Paris Universal Exhibition in 1867; by then Muybridge had become his partner.

It is in this year that we first hear definitely of his own work. In the spring and summer he organized an expedition to the Yosemite Valley, making whole plate ($8\frac{1}{2}$ × $6\frac{1}{2}$ inches) negatives and (5 × 3 inches) stereoscopic slides of the largely unknown territory.

These days the wet plate process is only used in the block-making industry and few people alive today can have any idea of the difficulties involved in using the system under the conditions Muybridge experienced. Imagine yourself standing in a small, opaque tent which the Californian sun turns into a furnace. Taking a sheet of glass, you pour on to it a quantity of collodion containing potassium iodide, tilting and twisting the plate so that it is evenly coated (this is an art in itself; a beginner usually tips the collodion from the corner of the plate straight up his sleeve). The coated plate is immediately dipped in a silver nitrate bath, placed in the dark slide and exposed in the camera as quickly as possible, for the ether quickly evaporates from the collodion and the plate soon becomes insensitive.

After exposure, which would be between ten and ninety seconds, depending on the light and the lens, the still wet plate had to be developed, pyro or protosulphate of iron being generally used. It was then fixed in hypo or the dangerous potassium cyanide, washed and dried. You had to carry the darkroom and all the necessary chemicals with you wherever you went.

Dust, insects and sweat fell on the plate; the ether fumes made you dizzy; unless the coating was quite even the negative was streaky; the process had no latitude and several attempts were often needed before the correct exposure was obtained; and, since enlarging was almost unknown, if you wanted a big print you had to use a big camera. Yet Muybridge took his equipment on pack mules into the wilderness and returned with some of the best landscape pictures ever made.

Towards the end of February 1868, Muybridge, under the name of 'Helios, the Flying Camera' was offering a collection of twenty whole plate prints of the Yosemite Valley for $20. Reviews of his work in the press were good – the rainbows, the cataracts, the mist and the sun peering through

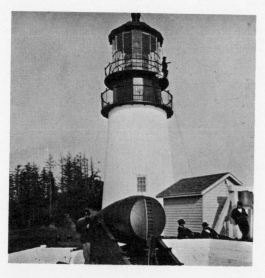

One of Muybridge's earliest photographs, taken for the Lighthouse Board in 1868

the clouds are all mentioned. But the thing that drew special comment was the way in which he produced cloud effects.

The wet plate process had a very high contrast and was sensitive only to blue and ultra violet light; if you gave enough exposure to record the detail in the foreground, the sky would be overexposed and blank. If, on the other hand, you gave an exposure short enough to record the clouds in the sky, the foreground would be hopelessly underexposed. Muybridge, however, had either learnt or worked out for himself a method of adding clouds to a blank sky, either by printing them in from a separate cloud negative or by dextrous hand work with a brush. He used the technique for many years, but later discovered he could use the rising front on his camera to take advantage of the fall-off in light towards the edge of the field covered by the lens; the sky would receive many times less exposure than the foreground.

He also became known for his 'moonlight' pictures, which he produced by combining a negative of a strongly backlit landscape with one of backlit clouds, a small opaque disc being added to the latter to represent the moon. If the two negatives were given a very full exposure during the printing process, the effect really did look as though it had been taken at night. To the photographically unsophisticated public of the period the pictures must have looked quite genuine; even today, when everyone realizes they are fakes, we can admire the skill with which they were made.

So outstanding was the quality of Muybridge's work that later in 1868 he was made Director of Photographic Surveys for the United States Government, a grand-sounding title that still involved him in much physical toil. He was employed by the Treasury, the War Department and the Lighthouse Board to take pictures of the West Coast and in Wyoming and Montana, then largely unmapped.

Alaska was purchased by the United States from Russia in the same year and Muybridge was asked to accompany General Halleck on an expedition to survey all the ports and harbours which might be useful to the military. This brought a completely new set of problems, for while he had the advantage of being able to use a darkroom on board the expedition's steamer, the *Queen*, he had to deal with sub-zero temperatures and an impossibly long range of tones, from the glare of the snow to the dark hull of the vessel. However, Muybridge had a natural eye for composition and the results, considering the material available, are excellent.

Back in California he started a series of pictures on wine production that was not finished until 1872. When marketed the series of eight prints showed the soil being ploughed, the young vines growing, the grapes being cut, loading them on to wagons, the casks and the bottling. A Boston newspaper

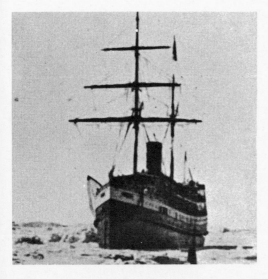

The steamer Queen *in Glacier Bay, Alaska*

The end of Glacier Point, Yosemite Valley

compared them with the work of Millet and they were undoubtedly far above the standard of the ordinary industrial record.

In 1869 he invented one of the first efficient camera shutters and returned to the Yosemite Valley, this time taking a very large camera that used 20 × 24-inch plates. His expeditions lasted several months and all his supplies, in addition to his photographic equipment, had to be carried with him on a string of mules. The results by any standard, modern or contemporary, were outstanding and six months of travel in 1872 earned him $17,000, a very large sum at the time. The work of Helios, the Flying Camera, became known in Europe and his Yosemite pictures won him a medal at the Vienna Exhibition.

While his Yosemite pictures were greatly admired by the general public, rival photographers were naturally not so enthusiastic. One firm, Thomas Houseworth & Co., even went so far as to exhibit a scrapped print of Muybridge's in their window to show the poor quality of his work.

In reply, Muybridge inserted a notice in the newspaper:

'Aesop in one of his fables relates that a miserable little ass, stung with envy at the proud position the lion occupied in the estimation of the forest residents, seized some shadowy pretext of following and braying after him with the object of annoying and insulting him. The lion, turning his head and observing from what a despicable source the noise proceeded, silently pursued his way, intent upon his own business, without honoring the ass with the slightest notice. Silence and contempt, says Aesop, are the best acknowledgements for the insults of those whom we despise. MUYBRIDGE.'

Late in 1871 or early in 1872 he married, at the age of 42, a divorcee named Flora Stone. The foster daughter of a Captain W. D. Shallcross, she was very much younger than Muybridge and one suspects things went wrong from the start. For the next couple of years Muybridge travelled away from home a great deal and threw himself into his work.

California at that time was a place of extraordinary contrasts. Indians lived the life of the Stone Age, the mountains and deserts hid wild animals and wilder men, but towns such as San Francisco and Sacramento were relatively sophisticated and many of the wealthier people who lived in them kept fairly closely in touch with scientific and artistic developments in Europe.

One of the wealthiest was ex-Governor Leland Stanford, President of the Central Pacific Railroad and of the Pacific Mail Steamship Company, who a few years before had driven the final spike into the track that connected the Pacific and the Atlantic Oceans. He lived in great splendour on a vast estate at Palo Alto, some thirty miles south of San Francisco; the mansion was surrounded by ornamental gardens, paths led through a mile of the

grounds to the stables where Stanford kept over 200 blood horses and nearby was his private racecourse, for his ambition was to breed the finest trotting and race horses in the world.

The pride of the stable was Occident, a small wiry horse that has earned a place in the history of photography. Foaled in 1863, he was thought to be vicious and was sold to a Sacramento butcher. The butcher in turn traded him to an earth-hauler and in 1869 as he was pulling at a huge load of sand, he was noticed by a German grocer with an eye for a horse. The grocer bought him, trained him, made him docile and changed his name to Charley. The grocer sold him to a Mr McMahon, who sold him to a Sydney Eldred for $300. In July 1870, Stanford gave $4000 for him and he quickly became the most famous trotter in the world.

There are several versions of the events that led up to Muybridge's taking one of the most important action pictures in history, but the following is probably correct. One day in 1872 Stanford and another millionaire horse-lover, Fred McCrellish, were discussing the way in which the legs of a horse move when trotting and galloping. They had been reading an article by Dr Etienne-Jules Marey, Professor of Medicine at the University of Paris, in which he described experiments he had carried out into the subject of animal locomotion. Fixing a rubber bulb on to each of the horse's hooves, he led a tube from each to four pens resting on a revolving drum of paper, strapped to the saddle. As each hoof struck the ground, the pen made a mark and the results, if correct, showed that a horse's legs moved in a very unexpected manner, all four feet sometimes being off the ground at the same time. McCrellish said this could not possibly be true and suggested to Stanford that he should hire Muybridge, the best-known photographer on the Coast at the time, to try to solve the argument by photography.

Other versions are that Stanford bet McCrellish $25,000 that all four feet would be off the ground at one time – this is unlikely; Stanford was not a betting man – or that Stanford wanted a painting of Occident at speed but didn't like the way in which artists portrayed the movement. A third version, printed in the *Alta California* in April 1873, claims that Stanford wanted Occident to beat his great rival, Queen of the Surf, and used photography to try to discover how he could obtain maximum performance from his horse.

These days, of course, the problem would present little difficulty. Even if the camera were loaded with a 'slow' film with a speed of perhaps 25 ASA, one would set the shutter at 1/1000th of a second, the stop at about f2.8 if the weather were sunny and keep taking pictures until one of them gave the answer. But the speed of wet plate was probably 250 times slower than this and the maximum aperture of the lens available could not possibly have

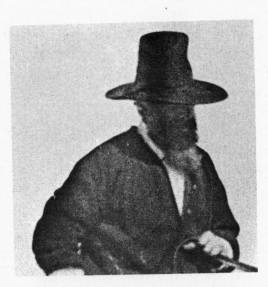

Eadweard Muybridge, c. 1872

been greater than f3 (presuming a 15cm Dallmeyer portrait lens was used) and was probably nearer f4.

The exact speed of wet collodion is difficult to determine, but in bright sunshine, with a lens that probably had an aperture of around f16, the exposure needed for a landscape was about ten seconds. This would make the ASA speed of the material about ·1. However, Muybridge was not interested in obtaining a correctly exposed picture with a full range of tones; provided the negative showed the relative position of the hooves at a given moment, a mere silhouette would serve to settle the argument between Stanford and McCrellish.

Realizing this, he decided to use both a white background and a white track over which the horse could trot. These were manufactured by borrowing all the bedlinen in the area round the Sacramento race course, where the tests were run (Stanford's influence must have been very great; few people will lend you the sheets from their bed if they know a horse is going to gallop over them).

The first day's work produced nothing at all, since the exposure given was far too long. On the second day Muybridge worked his shutter by hand as rapidly as possible and was rewarded with a vague blur. On the third day he used a shutter formed by two wooden blades with an eight-inch slit between them, sliding vertically in a grooved frame. A spring under tension pulled the blades down in front of the lens very rapidly and Muybridge calculated that he was obtaining a shutter speed of 1/500th of a second. A picture was finally obtained that he claimed showed all four hooves off the ground at the same moment, but the quality of the negative was very poor and the result was still open to argument.

It is hard to understand how he obtained a result at all. Little was known about shutter design in those days and the one being used must have had a very low efficiency. Ideally, the blades of a shutter open and close instantaneously, so that at any speed the whole area of the lens is completely uncovered from the moment the exposure begins to the moment it ends. In practice this ideal is never achieved and the efficiency of a shutter is measured by comparing the amount of light it could pass if it were perfect with the amount of light it actually does pass. With Muybridge's shutter the light could never pass through the whole of the lens at any one moment, only through an eight-inch wide section of it.

The negative must therefore have been either hopelessly underexposed, even for a silhouette, or else Muybridge was giving a very much longer exposure than he imagined. Probably the poor quality of the result was due to a combination of both circumstances.

If better theoretical knowledge had been available he would have concentrated on making the blades travel at the highest possible speed while using a wider slit, but at the time shutter design was in its infancy.

At this period of his life Muybridge was employed by Bradley and Rulofson of San Francisco, though perhaps it would be more accurate to say that they acted as his agent. They ran the biggest and best-equipped studio on the West Coast and were also the leading dealers in photographic apparatus. About the middle of 1873 they commissioned him to take stereoscopic pictures in Northern California of the Modoc Indian War, one more stage in the extermination of the Indians by the settlers. This tragic war, though little known, was the most costly of all the attempts to subdue the original inhabitants of the country. Between fifty and sixty Modoc warriors under their young chief, Captain Jack, fought twelve hundred soldiers for five months; the war cost more than half a million dollars and the lives of eighty-three white men.

Trouble began in 1869 when the Department of the Interior ordered their Indian Agent to move the Modocs to a new reservation in Oregon that belonged to their enemies the Klamaths. To escape persecution, a small band led by Chief Kientpoos (Captain Jack) and his sister Queen Mary returned to their old hunting grounds in the Lost River country, just over the Californian border. The Indian Agent asked for cavalry to herd them back again and in spite of the protests of the commanding officer, General Canby, a troop was despatched from Fort Klamath in 1872.

A fight resulted in which several were killed on both sides. The Indians retreated to the extinct volcanic region around the Tula Lake known as the Lava Beds and hid in the caves, while the soldiers waited for reinforcements. Eventually four hundred troops were assembled and an attack was launched on 17 January 1873. At the end of the day no one had even seen an Indian but thirty-nine soldiers were dead.

Still more reinforcements arrived and on 11 April General Canby made a brave attempt to stop the fighting by riding forward with four Peace Commissioners to meet Captain Jack under a flag of truce. Without warning the chief shot him dead and one of the Peace Commissioners was killed at the same instant by Boston Charley. The rest escaped, wounded.

The troops now advanced very slowly, step by step, until they had surrounded the Indians and cut off their water supply. On 21 April the desperate Modocs divided into two groups and tried to fight their way out; despite the huge odds against them they managed to cut one detachment to pieces before most of them were captured.

Captain Jack broke through and remained free until he was captured

'A Modoc Warrior on the War Path'

on 1 June. At Fort Klamath, he was hanged with three other chiefs for the murder of General Canby; the rest of the Modocs were banished to a reservation in distant Kansas, a sad end for a brave people.

Muybridge's stereoscopic prints of the war were sold in sets by Bradley and Rulofson and around this time Muybridge must have dropped the anonymous 'Helios' for the prints are printed 'Photographed by Muybridge'.

On his return from the Modoc War a very ugly and sordid period in his life began. However, no biographer should attempt to gloss over the events, since they must have had a very great influence on his work and on his character.

On 29 April 1874 it was reported in the *Sacramento Union* that a son had been born to Flora. Muybridge accused her of infidelity, presumably because the child was conceived while he was covering the Modoc War, and discovered she had a lover, another Englishman named Harry Larkyns. Muybridge and his wife continued to live together until June, when she went to stay with friends in Oregon, and on 19 October it was stated in the *San Francisco Examiner* that Muybridge had shot Larkyns dead and had been arrested.

On 11 January 1875, while he was in prison, his wife sued for divorce on grounds of extreme cruelty, asking for alimony, but the case was dismissed.

The murder trial dragged on and it was not until 7 February that the *Alta California* reported his acquittal. His hair and beard are said to have turned white in the meantime.

On 9 March Flora applied once again for alimony, this time in the District Court, and the grounds for divorce were examined more closely. The 'extreme cruelty' consisted in the fact that Muybridge had looked through the bedroom window, saw her sleeping on the bed, and then retired. The rather stunned judge said 'he thought that a husband had a perfect right to look upon his wife when she is asleep, and that such an act could not be construed to be cruelty'.

The determined Flora once again sued for divorce and alimony on 1 April 1875, but on 14 August the *San Francisco Bulletin* states that the action had been dismissed, Mrs Muybridge being recently deceased.

Muybridge supported the child, Florado H. Muybridge (H. for Henry?) until he grew to manhood. He worked as a gardener in San Francisco until he was knocked down and killed by a car in Sacramento on 1 February 1944.

As soon as he was acquitted, Muybridge left California for Central America. Leland Stanford must have taken a great liking to him when he was photographing Occident for he gave him a commission, with the blessing of the Harbour Board, to photograph 'all the curious places that a traveller by Railroad and the Pacific Mail Company's ship can see or be within reach of in a journey from New York to San Francisco with the Isthmus', or so

a Panama paper rather optimistically reported on his arrival. For the next six months Muybridge tried to erase the terrible memories of the previous year by engaging in a frenzy of work, taking hundreds of pictures in Mexico, Guatemala and Panama. These have an extraordinarily modern look about them, as though they had been taken by a very good photojournalist.

On arrival in Panama he started photographing the ruins of the Old City, cutting away trees and brushwood in order to obtain a clear view. Castles, churches, volcanoes, lakes. . . . Out of the great number of pictures he took, eighty were selected as perfect. On 1 May he left Panama for Guatemala in the S.S. *Honduras* and on arrival plunged into the jungle to take 400 pictures of villages, Indians, the ruins of Antigua, and a most important series showing how coffee was cultivated, the first time the industry had ever been photographed.

He must have been possessed by an almost lunatic energy Admittedly he had the power and money of the Pacific Mail Company behind him and there would be little difficulty in having his camera, tripod, darkroom tent, glass plates and all the chemicals carried through the forests. But he still had to coat, expose and process the plates in the heat and the humidity, he still had to walk or ride through country and amongst people that made the Yosemite Valley seem like a city park.

By 1 October he was able to print a letter for circulation to the wealthier people of Guatemala, offering prints for one peso each, provided at least twenty were ordered. It is signed 'Eduardo Santiago Muybridge'.

On 1 November he was back in Panama City and recommenced his task of photographing the area. On 5 November the National troops and officers, complete with their artillery, were formed up in the Cathedral Plaza for him to record and a few days later he sailed for the island of Taboga, ten miles off the coast, where he took pictures of the remains of the Pacific Steamship Navigation Company's deserted buildings. As in Guatemala, he made specimen prints from which people could select the ones they preferred 'which will be sent from San Francisco, where they will be printed under the superintendence of Mr Muybridge', as the *Panama Star* reported (1 November 1875). It also mentioned he was returning to the United States shortly.

It is an odd fact that every authority consulted states that Muybridge stayed in Central America until his wife died 'in 1877', when he returned to San Francisco, but his wife's death was reported in both the *San Francisco Examiner* and the *Alta California* on 19 July 1875, and by the *Stockton Independent* on the 20th. Muybridge was probably back in San Francisco by the end of November of the same year and in 1876 was advertising his South

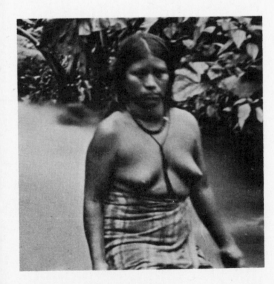

A Guatemalan woman

American pictures in that city. He offered purchasers a choice of 120 prints out of the 260 available for $100 in gold. He is said to have made $50,000.

According to the advertisement, he was charging only half his normal rate, thanks to the backing of the Pacific Mail Company. It also stated that he had 'made arrangements for the publication of these views in Europe and proposes sending on the negatives immediately the home subscribers are supplied'. If he kept his promise, it is possible that somewhere in Europe Muybridge's Central American negatives still exist, unrecognized and awaiting a researcher.

In the early summer of 1877 he succeeded in the ambitious project of taking a panoramic view of San Francisco, using sixteen 20 × 24-inch plates. For his viewpoint he selected the tower on the top of the palatial home of Mark Hopkins on the corner of California Street Hill and Mason Street, from where he could record the surrounding country as well as the city. Starting from the West, the picture shows Point Bonita, Tamalpais, Petalama, Sonoma, Napa, Vaca Vallies, Mt Diablo, Mt San Bruno, Mission Peaks, Lone Mountain, San Francisco Bay and its windjammers, Angel, Alcatraz, Goat and Mission Islands, the Alameda Plain, Long Bridges, Telegraph Hill, Ricon Hill, Potrero Hill, the Bernal Heights and Mission Ridge. It was estimated at the time that the homes of more than a quarter of a million people could be seen.

It was a tremendous technical feat; the print, nearly twenty-seven feet long, is still an astonishing sight. Muybridge must have had a large number of helpers, one coating the plates and putting them into the darkslides, another carrying them from the darkroom to the photographer who, immediately after exposing, would hand the slide to a third assistant who would carry it down to a different part of the darkroom where the processing was going on. Speed was essential to avoid both changes in the light and changes in the emulsion, which lost speed as it dried.

The huge negatives were contact-printed and it must have been a considerable relief when it was found that they all joined up evenly. Mounted on a linen backing and folded concertina-fashion, the panorama was sold protected by leather-covered boards, so that it looked rather like a very big book.

In the middle of 1877 he was invited by Stanford to resume his experiments into the movements of horses, again at the Sacramento track. The earlier picture had convinced Muybridge that it was possible to obtain a sharp result, but it was not good enough to convince many others. However, during his work in Central America he had been faced with the problem of photographing objects on shore from the deck of a rolling ship and it was reported that he

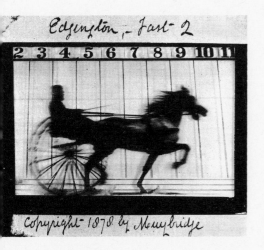

Photograph of Edgington in motion, 1878

had devised new mechanical and chemical methods to make this possible. In other words, he had constructed a more efficient shutter and had either found a way of increasing the speed of wet collodion or else had worked out a more energetic developer.

Occident was used for the tests once more and on 2 August 1877, Muybridge was able to send the *Alta California* a sharp picture of the horse trotting by the camera at 24½ mph. It was accompanied by a letter addressed to the Editor, but Muybridge's own copy of the published letter has written across it in his handwriting 'Letter to McCrellish', so presumably McCrellish ran the paper. It is sufficiently important to quote in full.

San Francisco, August 2nd 1877.

Editors Alta,

When you did me the honor of asserting to Gov. Stanford your confidence in my ability to take a photograph of 'Occident' while he was trotting at full speed – provided I could be induced to devote my attention to the subject – I will candidly admit I was perfectly amazed at the boldness and originality of your proposition. Having, however, given my patient devotion to the task the Governor imposed upon me, and instituted an exhaustive series of experiments with chemicals and apparatus, it affords me pleasure to submit to you proof that your flattering confidence in the result of my endeavors was not altogether erroneous, and I herewith enclose you a photograph made from a negative, which I believe to have been more rapidly executed than any ever made hitherto.

The exposure was made while 'Occident' was trotting past me at the rate of 2:27, accurately timed, or 36 feet in a second, about 40 feet distant, the exposure of the negative being less than the one-thousandth part of a second. The length of exposure can be pretty accurately determined by the fact that the whip in the driver's hand did not move the distance of its diameter. The picture has been retouched, as is customary at this time with all first-class photographic work, for the purpose of giving a better effect to the details. In every other respect, the photograph is exactly as it was made in the camera.

I am, yours faithfully,

EDW. J. MUYBRIDGE

Muybridge had taken the picture by means of a 'double slide' shutter, presumably basically similar to his previous shutter which had two wooden slats sliding in a grooved frame with a slit between them, exposing the plate as it slid past the front of the lens. This time, however, he overcame the inefficiency of the arrangement by using two pairs of slats, one sliding down as before and the other sliding upwards. If in both cases the slit were as wide as the diameter of the lens, there would be a brief moment when the whole of

the lens was uncovered, giving a much greater light intensity than before and at the same time a higher speed.

It is a pity that the negative was retouched (by a man named Koch) because this made many people say the whole thing was a fake. The *San Francisco Evening Post*, for instance, devoted two columns in September to giving reasons why the picture was a fraud. The driver, James Tennant, is sitting upright instead of leaning forward; his coat sleeve is unwrinkled; the horse's legs are the wrong length; it could not possibly extend its leg forward when trotting; an instantaneous picture is not taken at less than one-tenth of a second; it is impossible to measure one thousandth of a second; and so on. Similar objections came from knowing people throughout California, and Muybridge did not help matters by being unwilling to sell prints, though he distributed many to the press.

The jurors at the San Francisco Industrial Exhibition, however, awarded him a medal for the picture later on in the year. Muybridge announced that he was continuing his experiments and hoped to produce a series of photographs that would show every stage of movement in a horse's legs when galloping.

The single photograph of Occident was startling, but from Stanford's point of view it didn't supply all the information he needed about the way in which a horse moved. If Muybridge continued to take single pictures of the horse as it passed the camera it might be possible eventually to obtain a series of pictures that would show every stage in the stride, but the labour would be immense and much would depend on luck. Instead, he asked, would it be possible to line up a number of cameras and take pictures in quick succession?

Muybridge started working on the problem at once, assured by Stanford that money was no object. He ordered twelve specially designed cameras from England, where the best cameras in the world were being made, and had them fitted with matched lenses made by Dallmeyer of London. He once again used the 'double slide' shutter, attaching very powerful springs to both the rising and falling blades. The slits were adjusted so that as they crossed a two inch gap would appear in front of the lens; if he was using just the centre of the field of a Petzval portrait lens with a focal length of about eight inches, as seems possible from the small size of the negatives he produced, this would give the aperture as f4, presuming it was realized that the whole area of the lens had to be uncovered by the shutter to obtain maximum efficiency.

In use, the shutter blades were tensioned and held back by a catch. This was operated by an electro-magnet which, when energized, released the catch – exactly the same system that is used in modern 'electronic' focal plane

IN THE AIR

THE FIRST CONTACT.

Drawings from an article in the San Francisco Stock Exchange *of 8 May 1880 about Muybridge's experiment at Palo Alto, June 1878*

Cutting from Anthony's Bulletin, *September 1878*

shutters. The electrical side of the apparatus was designed and made by the San Francisco Telegraph Supply Company.

By the middle of June 1878 the results obtained were so good that Stanford felt confident enough to call a press conference and give a demonstration. It was held at Palo Alto, where the experimental work had been done, and reporters from various San Francisco and Sacramento papers came by train to Menlo Park Station and from there travelled the short distance to 'The Farm', as Stanford's estate was known.

Luckily it was a fine morning, a slight mist had cleared early, and the haymakers were at work as the party passed through the fields on their way to the track. Perhaps the best account of what happened is given in *Pacific Life*, 22 June 1878.

'The most important experiments ever made in connection with electro-photography were brought to a successful conclusion on Saturday last, in the presence of Governor Stanford and a few invited guests at his race track at Palo Alto. The experiment in question was to reproduce the action of a horse at every point in his stride when trotting at a 2:20 gait, and as already mentioned the result was so successful as to be beyond the cavillings of a few sceptics whose admirably propounded axioms in this respect are thoroughly put to nought. To Governor Stanford must be accorded the merit of first broaching to Mr Muybridge the feasibility of the plan, and to his liberality in furnishing the funds for a series of costly experiments must be ascribed the present success; but to Mr Muybridge great praise is due for the skill shown in the succession of experiments made that step by step have resulted in such a grand impulsion in the history of the photographic art.

The apparatus employed on this occasion was very simple, but yet showing an immense deal of study, ingenuity and insight. On one side of the track is a rough shed in which are the lenses and cameras, twelve in number, and on the opposite side is a huge screen of white canvas stretched over a scantling fence some thirty feet long and eight feet high, with a backward declination of some sixty degrees. On the upward edge of this canvas are shown the figures 1 to 20 consecutively, severed by vertical cords at 21 inches distant, and at the bottom of this canvas was a board showing horizontal lines that represented four, eight and twelve inches above the track.

About two feet from the same canvas, but on the track, was a slight wooden ledge and between the two at every number between 4 and 16 were stretched a galvanic wire at almost an inch from the ground, each connecting with its numbered lens on the opposite side, the wires being taken underneath the track. The investigation thus far was very simple, as it was apparent that the inner wheel would pass over the projecting wires and by a simple

24

THE CALIFORNIA HORSE—ELEC-TRIC FEAT.

THE following will interest those who "take stock" in the wonderful California horse story.

"None know better than yourself that the country is full of photographic quacks vending their nostrums, deceiving the credulous, and defrauding the ignorant. California is noted for its 'largest pumpkins,' 'finest climate,' and most 'phenomenal horse' in the world. So also it has a photographer! the dexterity of whose "forefinger" invokes the aid of electricity in exposing his plate—a succession of plates, so as to photograph each particular respiration of the horse. The result is, a number of diminutive *silhouettes* of the animal on and against a white ground and wall; all these in the particular position it pleased him to assume, as the wheels of his chariot open and close the circuits. All this is new and wonderful. How could it be otherwise, emanating as it does from this land of miracles? Photographically speaking, it is 'bosh;' but then it amuses the 'boys,' and shows that a horse trots part of the time and 'flies' the rest, a fact of 'utmost scientific importance.' Bosh again.

"Respectfully, your friend,

"WM. H. RULOFSON."

Cutting from the Philadelphia Photographer, *August 1878*

arrangement on the other side would close the circuit. But then arose the question as to how this could be utilized to take a picture in the estimated incredible fraction of time of the two-thousandth part of a second – in which period the lenses had to be exposed and closed. This was effected by a very ingenious contrivance in the shutters of the cameras, to the upper and lower parts of which were adjusted very powerful springs, and when the electric current was perfected they were released, and in crossing they exposed a space of about two inches, and in this space of time that represented but a flash of lightning, the passing figure is fixed on the highly-sensitized glass, even to the minutest details. The ground over which the experiment was to be made being covered with slack lime, so as to catch even each footstep of the stride, all was duely prepared, and Abe Edgington, with Charles Marvin holding the reins, appeared on the track to show by twelve almost instantaneous photographs the true story of the stride of a horse.'

The horse trotted by, the wheel passing over the wires with a noise 'like the wings of a woodcock' and the press crowded into the darkroom to see the pictures developed. The result, seen by the light of the yellow window let into the side of the shed, looked almost magical.

Apparently some slight doubts remained in the minds of the more cynical journalists, but even they were convinced by what happened next. The Kentucky racing mare Sallie Gardner was brought out to gallop past the cameras. The previous arrangement of wheel-operated wires could not of course be used, so threads were stretched across the track which would operate the shutters as the mare broke them on her way past the cameras.

She hesitated, the saddle girth snapped and she bounded forward. On developing the plates, every detail of the incident, even the broken girth, was shown and doubts were no longer possible. After a very good lunch the press dispersed to tell the world of the wonderful invention.

Accounts of the experiments spread throughout Europe and America and caused a sensation. It was calculated that the twelve pictures were taken in about half a second, the same speed at which a modern movie camera exposes its frames (a motor-driven 35mm camera works at about 3 fps), and to people who had never seen pictures of fast action, let alone sequence pictures, the whole thing came as a revelation.

Muybridge calculated that his shutter speed was 1/2000th of a second, but this was probably an over-estimation. The movement of the horse's legs could have been stopped by a shutter speed of 1/1000th or even 1/700th and using wet collodion at f4, even in Californian sunshine and even producing a mere silhouette, it is doubtful whether he would have obtained a result at the higher speed.

Several improvements were made in the technique. The track was covered with white corrugated rubber, to prevent the dust from rising. A clockwork mechanism was also developed that would fire the shutters in turn by means of a rotating wipe contact; this is said to have been invented by a John D. Isaacs of the Central Pacific Railroad (it has not been possible to find proof of this) and it meant that by adjusting the speed of the clockwork the timing of the cameras could be adjusted to match the speed of the movement of any object, making the use of wires and threads unnecessary. And, by the summer of 1879, the number of cameras had been increased to twenty-four, giving a very complete analysis of movement.

Before this, however, the *Scientific American* in its issue of 19 October 1878 had made a suggestion which anticipated the motion picture. On its first page it published six drawings of Abe Edgington walking and twelve of him trotting, all made from Muybridge's photographs. If the readers cut out the drawings and mounted them in a zoetrope, said the article, the horse would apparently walk and gallop when the drum was revolved. (The zoetrope, invented in 1833, was a popular scientific toy. Looking rather like a lampshade with vertical sides, it consisted of a revolving drum with a strip of sequence pictures mounted round the inside. Each picture faced a slot cut in the opposite side of the drum and when it was revolved the pictures were seen briefly one after the other, giving an illusion of movement.) This article may have started Muybridge wondering if he could obtain similar results by projecting onto a screen.

Meanwhile, on 8 July, three weeks after the demonstration to the press, he discovered another talent of his own that was to take him all over Europe and America: he was a born lecturer. On that day he gave the first of a series of lectures in the San Francisco Art Association Rooms in Pine Street. 'Clever, lucid and humorous', he held the audience's interest for several hours, projecting his slides onto a fifteen-foot square screen by means of a projector fitted with oxy-calcium lighting ('limelight') and showing a very large number of pictures in quick succession. On one half of the screen he would project a painting of a galloping horse as seen by a famous artist, on the other would be shown one of his photographs of the way in which a horse really moved. The comparison made the artists look absurd.

He also showed some of his Alaska, Yosemite and South American pictures (telling funny stories about the latter) and a number of slides he had taken while travelling across America by rail, ending with his panorama of San Francisco. His first audience was disappointingly small, but on the second night the house was full and on the third it was crammed.

About this time he also registered several of his horse pictures at the

Opposite. Illustrations from an article in The Field, *28 June 1879*

Library of Congress, thereby copyrighting them, and sold them from Morse's Gallery, at 417 Montgomery Street, San Francisco; technical details were printed at the bottom.

Simultaneously, he was working on a document copying process which involved making a negative 'one sixth the original size' (probably one sixth of the area of the original, not one sixth linear) and a contact print. He charged 35 cents for making the negative and print and 13 cents for each additional print and suggested he should copy the County Records, provided he was given at least 20,000 sheets to work on, as a precaution against loss from fire. Everyone agreed the process was excellent and as proof of the way in which such copies would last Muybridge produced photographs of the Mexican State records which had been made as long ago as 1858 and which were still perfect, but the thought of paying out $10,000 proved too much for the Board, who decided instead to have the sheets copied by hand!

We now come to what is perhaps the most interesting and certainly the most controversial of Muybridge's activities, his invention of the motion picture. Both he and Stanford had experimented separately with his horse photographs in the zoetrope in 1879 and in June an electrically driven model was drawing crowds to the window of the *Field*, the London sporting paper, but the pictures were far too small and could only be seen by one person at a time. Muybridge decided to find some way of projecting his sequence photographs on to a screen, designing a mechanism that would let the image of each picture remain stationary for a fraction of a second and then blacking out the screen momentarily as the picture changed.

Other people had projected moving drawings on a screen and attempts had been made to manufacture moving photographs by building up a sequence of poses – in the early 1860s, for instance, Claudet had taken a series of stereoscopic daguerreotypes of himself raising his hat, pausing every few inches of the movement to let a fresh picture be taken, in the hope that, when shown in rapid succession, the illusion of movement would be obtained. But until Muybridge gave a lecture on the evening of 4 May 1880 at the San Francisco Art Association Rooms, during which he showed moving pictures of animals, no one had ever before projected moving photographs on a screen to an audience. To Muybridge belongs the honour of inventing the movie.

From time to time attempts are made to deny this by pointing out that since the number of his pictures was limited, only short sequences could be shown. Others point out that his projector incorporated several ideas that had been used by other people; this is quite correct, but it is just as logical an objection to say that he did not invent the lens he used or the oxy-calcium light. A completely original invention is a rare thing.

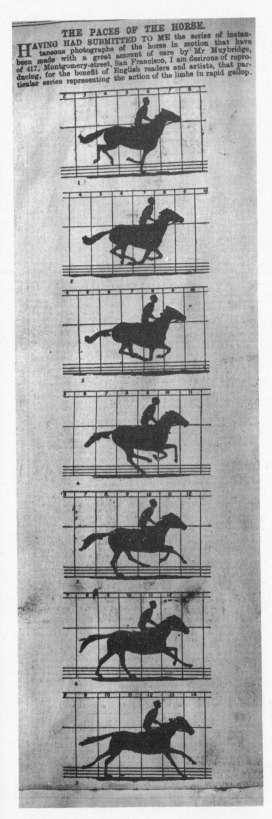

THE PACES OF THE HORSE.

HAVING HAD SUBMITTED TO ME the series of instantaneous photographs of the horse in motion that have been made with a great amount of care by Mr Muybridge, of 417, Montgomery-street, San Francisco, I am desirous of reproducing, for the benefit of English readers and artists, that particular series representing the action of the limbs in rapid gallop.

At first he called his projector the 'zoogyroscope' but by early in 1881 he had changed the name to the 'zoopraxiscope'. It consisted of the lamphouse and lens of a normal projection lantern, but instead of a slide carrier there was a mechanism whereby a glass disc, rather larger than a long-playing record, could be fixed vertically in the position normally occupied by a slide and rotated by turning a handle. A Maltese Cross intermittent movement was used to alternately hold the disc still while the picture was being projected and then move it on while the screen was blacked out by the rotating shutter. By later standards it was crude, but it worked.

With the material then available, wet collodion, it was probably the best method of making and showing movies that could have been devised, but it was incapable of further development. For a sequence to last more than a few seconds the disc would have had to be huge. Printing each picture from a negative on to exactly the right place on the edge of the disc must have been a tricky job. The disc was both heavy and fragile. But it showed what the world was waiting for, moving pictures.

His work at Palo Alto finished in 1879, except for a short visit in January 1880 to photograph an eclipse of the sun. At the end he was using twenty-four cameras, 12 inches apart, and in addition he had two extra sets of cameras to photograph the horses from different angles. The background was fifty feet long and fifteen feet high with a forty foot long camera shed on the other side in which was incorporated a darkroom. The total cost to Stanford is said to have been $40,000.

As his work became known, Muybridge entered into some correspondence which was to be of great importance. In the first place the American artist Thomas Eakins, famous for the photographic accuracy of his paintings, suggested he should place a graticule over the negatives when printing to make it easier to copy the photographs when drawing. He owned a set of the 1878 Palo Alto pictures and had made lantern slides from them for lecture purposes. Muybridge did not act upon his suggestion directly, but later on he devised a background for his pictures divided into squares like graph paper, which had the same effect.

Muybridge also exchanged letters with Marey via the editor of *La Nature*, the publication in which his pictures had appeared on 14 December 1878. Marey asked him if he could take some pictures of birds in flight and Muybridge replied saying he would start working on the problem in May 1879. He also said it was Marey's work which had inspired Stanford to start his enquiries into animal locomotion and as a mark of respect he asked his Paris agent Brandon to send Marey two complete sets of all the photographs he had taken to date.

While working at Palo Alto he continued lecturing in Sacramento, at the Congregational Church Hall, and in San Francisco at the Mechanics Fair and the Art Association Rooms. As far as is known, after his first showing of the zoopraxiscope on 4 May 1880, he did not demonstrate it again until April 1881, when it was shown to a much larger audience of scientists and journalists, who brought him world-wide publicity. He then set out with his wonderful machine on a lecture tour of America and Europe; he was in Paris in August 1881, met Marey and lectured daily to the Electrical Congress that was being held in the city.

As promised, he showed Marey some sequence pictures he had taken of birds in flight, but they were disappointing. Since the birds could not take their own photographs by breaking threads or tripping wires, the clockwork timer had to be used and it was almost impossible to synchronize this with the speed of the flight. As a result, Marey developed a 'photographic gun', which had a single lens and a revolving sensitive disc on which twelve exposures could be made in rapid succession. (He may have taken the idea of the disc from the zoopraxiscope.) Centering the approaching bird in the viewfinder he could swing ('pan') the camera, pressing the release as the bird flew by. It was infinitely easier to use than Muybridge's apparatus and must be considered as the forerunner of the modern cine-camera.

From the point of view of motion analysis, however, Muybridge's method was theoretically better, since each picture was taken by a camera at right angles to the subject. Only one of Marey's photographs was taken at right angles; in all the others the subject was either advancing or retreating.

Stanford was also in Paris and a rather comic situation developed between him and Meissonier, the famous French artist. Meissonier turned out the kind of heroic, naturalistic paintings that greatly appealed to politicians and millionaires then and had been backed by the Government to such an extent that they had even built a special track along which he could be pulled at the same speed as a horse trotting alongside him, in an attempt to capture the movement of the legs with complete accuracy. Stanford badly wanted him to paint portraits of himself and his wife, but Meissonier refused. However, Stanford had not made his fortune without knowing how to strike a bargain and gave Meissonier a few of the Palo Alto horse pictures, saying he could have the rest when the portraits were finished. The bait proved irresistible and the painting now hangs in Stanford University; it shows Stanford with one hand resting on a bound volume of Muybridge's pictures.

Meissonier was not too proud to admit that up to the time he had studied Muybridge's photographs all his interpretations of horse movements had been wrong and he actually repainted one of his works (*Friedland*) as a result.

Boston Daily Globe.

SUPPLEMENT.

SATURDAY, OCTOBER 21, 1882.

ANIMALS IN MOTION.

Science Upsetting the Theories
of Observation.

Instantaneous Photography Finds
Horses in the Air.

Professor Muybridge and His Queer
Zoopraxiscope.

Cutting from the Boston Daily Globe
of 21 October 1882

He was so impressed that early in 1882 he held the social event of the year, a meeting of all the best-known painters and sculptors in France to whom Muybridge showed his slides and moving pictures.

Between 1881 and 1883, Muybridge was in Britain and visited Manchester, Leeds, Sheffield, Bristol, Birmingham, Bath, Chatham, Oxford University, Eton, Rugby, Edinburgh, Glasgow, Belfast and Dublin. In London he lectured to the Royal Academy, the Royal Society, the Royal College of Surgeons, the Royal Geographical Society, the Linnaean Society, the Zoological Society and to many other organizations. Perhaps his most distinguished audience was at the Royal Institute, when the Prince of Wales took the chair and in the audience were the Princesses Alexandra, Victoria, Louisa and Maud, the Duke of Edinburgh, Earl Stanhope, Sir Frederick Leighton (then the President of the Royal Academy), Lord Tennyson, Gladstone, T. H. Huxley, and others.

Muybridge also lectured in Berlin, Vienna, Munich, Turin and other cities besides Paris and, in October 1882, he returned to the States to undertake his greatest work so far.

In his lectures Muybridge had shown moving pictures of athletes, acrobats, birds, deer and other animals besides horses. The problem of discovering the way in which humans and animals really moved was obviously a vast one, but to investigate it properly called for a much greater sum of money than Muybridge could command. He approached several organizations for help without success and finally aroused the interest of J. B. Lippincott, a wealthy man who had donated much money to the University of Pennsylvania. Lippincott approached the Provost, Dr William Pepper, who agreed to sponsor the work provided it was supervised by a scientific committee appointed by the University; William Eakins was a member and made various suggestions about the lighting that should be used, but was convinced that Muybridge was working along the wrong lines. He preferred Marey's single lens camera and eventually constructed one for himself, duplicating many of Muybridge's experiments.

Work started in the spring of 1884, the first step being to design a new, 'portable' camera. This had thirteen matched Dallmeyer lenses, one being used for viewing and focusing, and took twelve pictures on a single plate, thus greatly speeding up the work of loading, processing and printing. In size it was four feet long and eighteen inches square and three of them, connected electrically, were used on each subject to give front, back and side views. The clockwork timing device could expose twelve pictures in a fifth of a second, but such a fast sequence was rarely needed and the mechanism was usually slowed down to match the speed of the subject.

The background was designed to provide the greatest possible information to artists and scientists. It was first of all divided by cords into twenty-inch squares and then subdivided into two-inch ones; in effect it was like a huge sheet of graph paper. An artist using a sheet of squared-off paper could exactly match the position of the limbs and figure, while scientists could determine the extent of a movement. Light objects were photographed against a black background marked with white lines, while dark ones had a white background with black lines.

The distance between the camera and the subject was standardized, as far as was possible, at 49 feet. For slow movements which did not call for the highest possible shutter speed, lenses with a focal length of fifteen inches and an aperture of f5 were used, six inches apart. For fast movements, ones with a focal length of five inches and an aperture of f4 were preferred, three inches apart. With the latter the size of the negative was only $1 \times 1\frac{1}{2}$ inches (the same size as a modern 35mm frame) so only the centre of the field was being used.

After much experimenting, the colossal task was started. Over the next two years 100,000 pictures were taken of a wide range of human and animal activities, starting with an extraordinary series of nude male and female models running, jumping, climbing stairs, riding horses, playing cricket, rowing, boxing, performing acrobatics. Every time Muybridge made a sequence of some human activity he was breaking entirely new ground.

Most of the models were students and graduates of Pennsylvania University. It is a mistake for the photographic historian to take it all too seriously; Muybridge had a sense of the ridiculous and when he suggested that one nude girl should throw a bucket of water over another, that a mother should spank her child or that a man should play cricket without even the suspicion of a pad, he probably thought it all pretty hilarious. But no matter what action was performed, the results were invaluable.

In the summer and autumn of 1885 he concentrated on the animals in the Philadelphia Zoo, a much more difficult project since they could not be told what to do or where to go. The results were unique and in most cases have not since been repeated.

Luckily for him, gelatine dry plates, invented in England by Dr Richard Maddox in 1871, had, by the time Muybridge started his work at the University, been greatly improved and were commercially available in Philadelphia. Ten to twenty times more sensitive than wet collodion, they made it possible for an action picture to be taken that showed a full range of tones, though since they were only sensitive to blue light, sun-tanned faces recorded much too darkly. Muybridge used Carbutt's 'Keystone' plates,

coated at Wayne Junction, Philadelphia.

It must have been a great relief for him to be photographing humans instead of horses. There is a quotation from Thomas Hardy in Muybridge's clear, confident handwriting: 'I've suffered horse-flesh traipsing up and down, and can't find her nowhere.'

During this period Dr Francis X. Dercum was making a study of the normal and abnormal movements of human beings at Pennsylvania University and Muybridge's work was an invaluable help. As well as photographing young, athletic people he started to take pictures of grossly fat and deformed people.

The total cost of the work was over $30,000 and in order to recover some of the expense, a book was published in 1887, *Animal Locomotion: an electro-photographic investigation of consecutive phases of animal movement.* It consisted of 781 collotype plates, divided into eleven huge volumes, the text being written by Dr H. Allen, Professor of Physiology at Pennsylvania University. The price was $600 and this, of course, limited the market severely; today it is a very rare and valuable possession. For people who did not want, or who could not afford, the full collection, selections of one hundred plates for $100 were available.

Part of the value of the work lies in the quality of the printing, done by the Photogravure Company of New York. The collotype process, though only suited to short runs of work, gave results very close to that of original photographic prints. It was based on the discovery that if bichromated gelatine is exposed under a negative and then dampened, a greasy ink will stick to the parts of the surface which were affected by light, in proportion to its intensity. The image has a slight grain, due to the reticulation of the gelatine, but there is no screen pattern and the tonal gradation is usually very accurate.

In the following year, 1888, the world's first photo-finish in a horse race was made in New Jersey, following a letter written to *Nature* by Muybridge in May 1882, in which he said that he had no doubt that in the future a camera would be mounted opposite the winning post in all important races, to avoid dead-heats. This aspect of his inventive genius is still in use all over the world.

Muybridge left his work at Pennsylvania University to continue touring the United States and Europe. After a lecture in Orange, New Jersey, on 25 February 1888 he met Thomas Alva Edison, the inventor, amongst other things, of the phonograph. Muybridge suggested that the record player should be coupled to his projector so that voices could be combined with moving pictures. Edison was enthusiastic and offered to record the voices of people

such as Edwin Booth and Lillian Russell, while Muybridge made moving pictures of their gestures and expressions (of course, there was no suggestion that the two should be accurately synchronized; the zoopraxiscope could only keep repeating a short sequence over and over again). Eventually the idea was scrapped since Muybridge felt that the phonograph lacked the necessary volume for use with a large audience – a little more perseverance, and sound moving pictures might have been shown in 1888.

Edison was very impressed by the moving pictures he had seen and purchased a set of Muybridge's horse pictures. When he invented his revolutionary cine-camera, using the long perforated films we know today, he is said to have made his first movie by copying these photographs and then running the film through his projector.

Edison's kinetoscope, which could film comparatively long sequences, soon killed the public's interest in the zoopraxiscope and, in 1893, when Muybridge opened the Zoopraxographical Hall, at the World's Columbian Exposition in Chicago (it was on the Midway, amongst the sideshows) few people visited it and from 1 May to 31 October he only made just over $200; on the other hand he gave very few demonstrations – one feels he had lost interest himself.

He was back in England and at Kingston for a while in 1895, staying in a large house called The Chestnuts, but returned several times to the United States. In London, Chapman & Hall republished part of his *Animal Locomotion*, reduced in size from the original (some of the plates in the latter were 18 inches wide). Halftone blocks were used which allowed a very long run of printing but which did not give such good quality as collotype, and the work was produced in two volumes, *Animals in Motion* in 1899 and *The Human Figure in Motion* in 1901. Lantern slides were also available from G. W. Wilson in Aberdeen, to whom Muybridge had sent copy negatives of his work on sheet film.

In 1900 he returned to Kingston for good, sharing a house at 2, Liverpool Road with one George Lawrence. As energetic as ever, he dug a scale model of the Great Lakes of America in the back garden and planted sago palms and a ginkho tree (no trace remains of the Lakes, but the trees are still thriving).

On 8 May 1904 he died and was cremated in Woking. He left his zoopraxiscope, slides, scrapbook and *Animal Locomotion* to the Kingston Public Library (George Lawrence was his executor), together with the income from £3000 for the purchase of reference books. Many of the slides are now in the Science Museum in London, but the terms of Muybridge's will prevent the zoopraxiscope from leaving Kingston and it is still there, the Museum's proudest possession.

Muybridge's last house at Kingston-on-Thames

II The Photographs

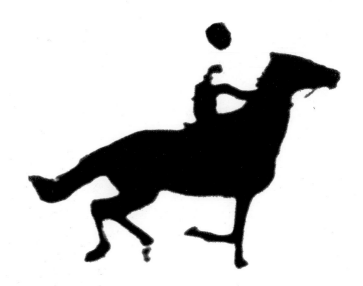

1 Alaska

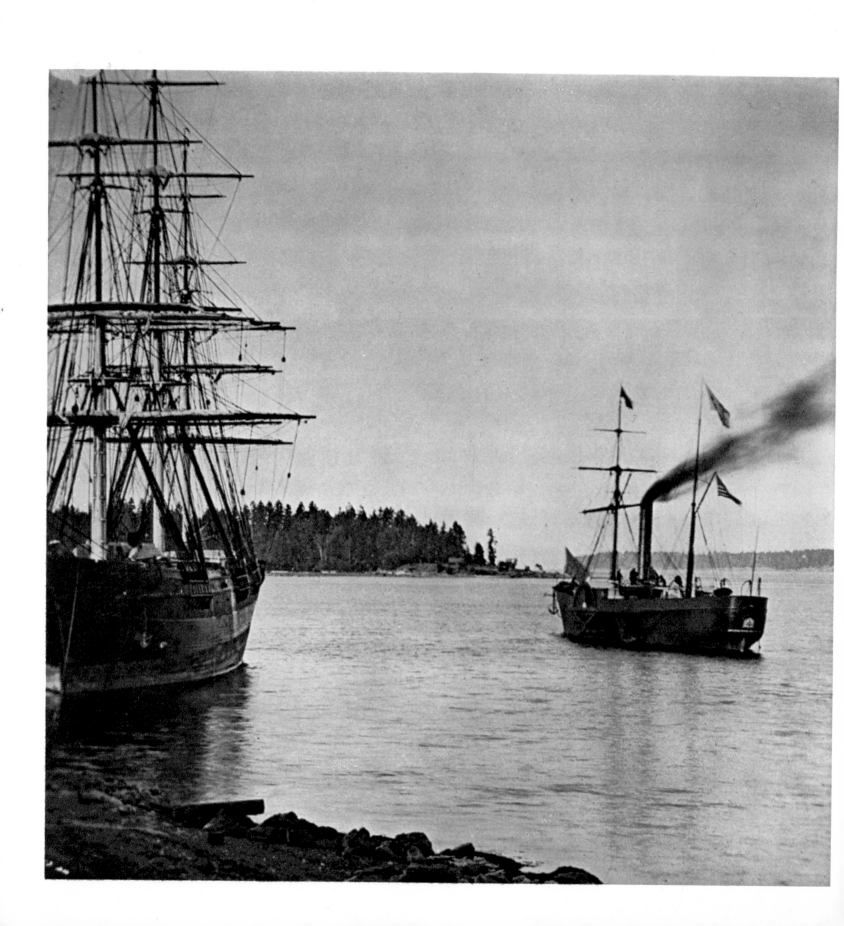

Left A small American steamer (not the *Queen*) moves slowly towards an anchorage. Nearly all steamers still carried sail at this period, due to the unreliability of the engines and the uncertainty of coal supplies.
Right One of the best of Muybridge's moonlight effects. Taken in bright sunlight against the light, the 'moon' has been added at the printing stage. The steamer closely resembles the *Queen*.

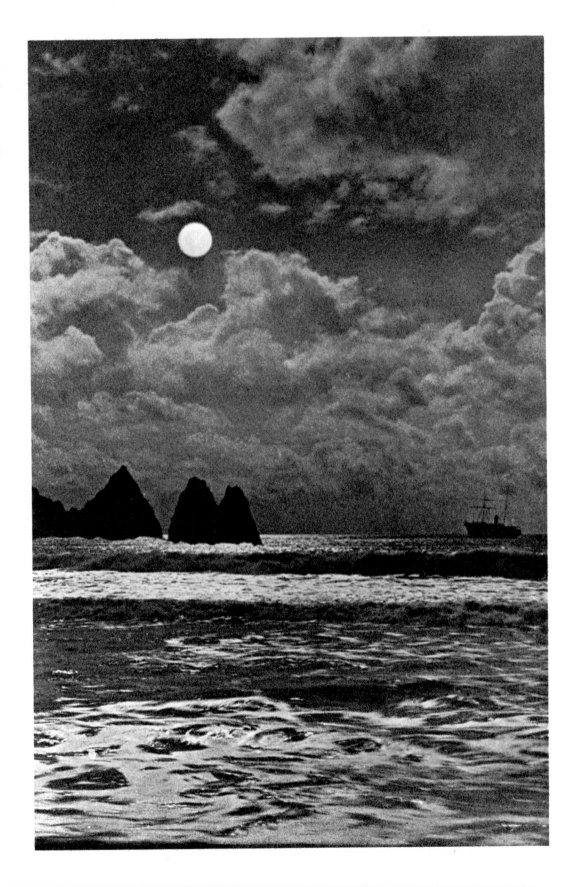

Captioned by Muybridge 'Steamer *Queen* among the Ice', the very long range of tones would make this a difficult subject to photograph with modern material; Muybridge succeeded with high contrast wet plates.

No. 1 1027 Alaska.

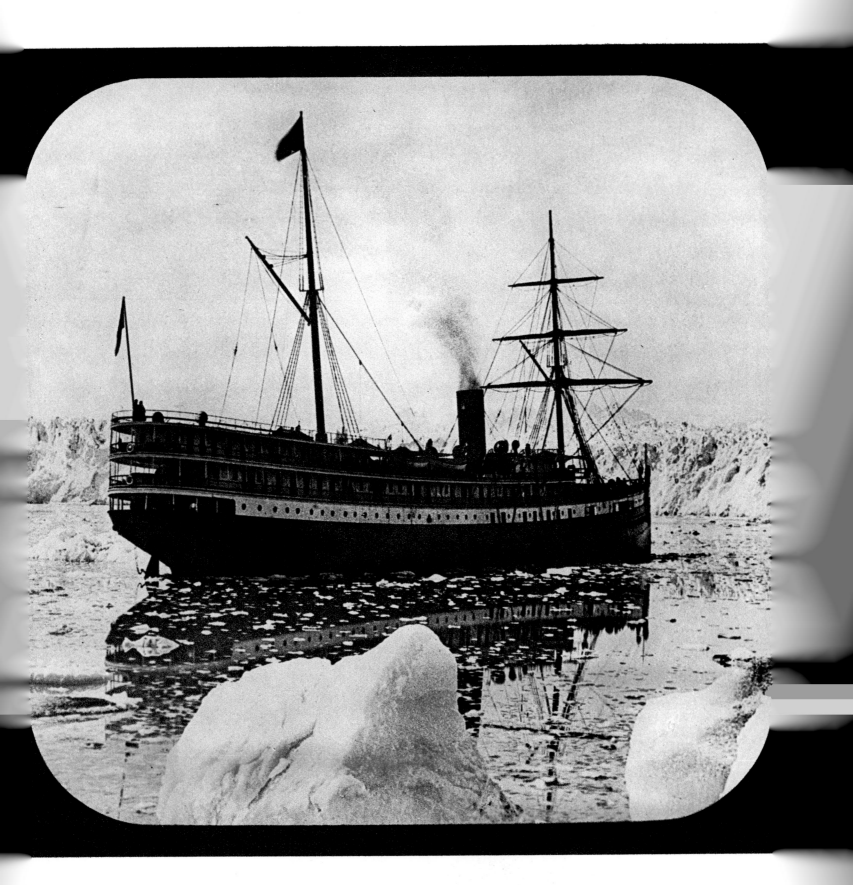

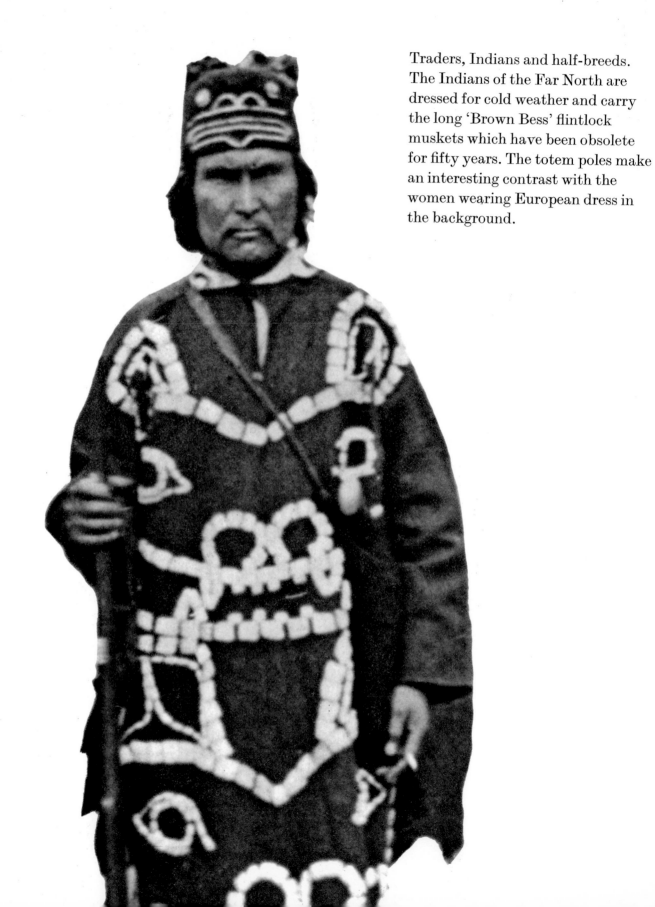

Traders, Indians and half-breeds. The Indians of the Far North are dressed for cold weather and carry the long 'Brown Bess' flintlock muskets which have been obsolete for fifty years. The totem poles make an interesting contrast with the women wearing European dress in the background.

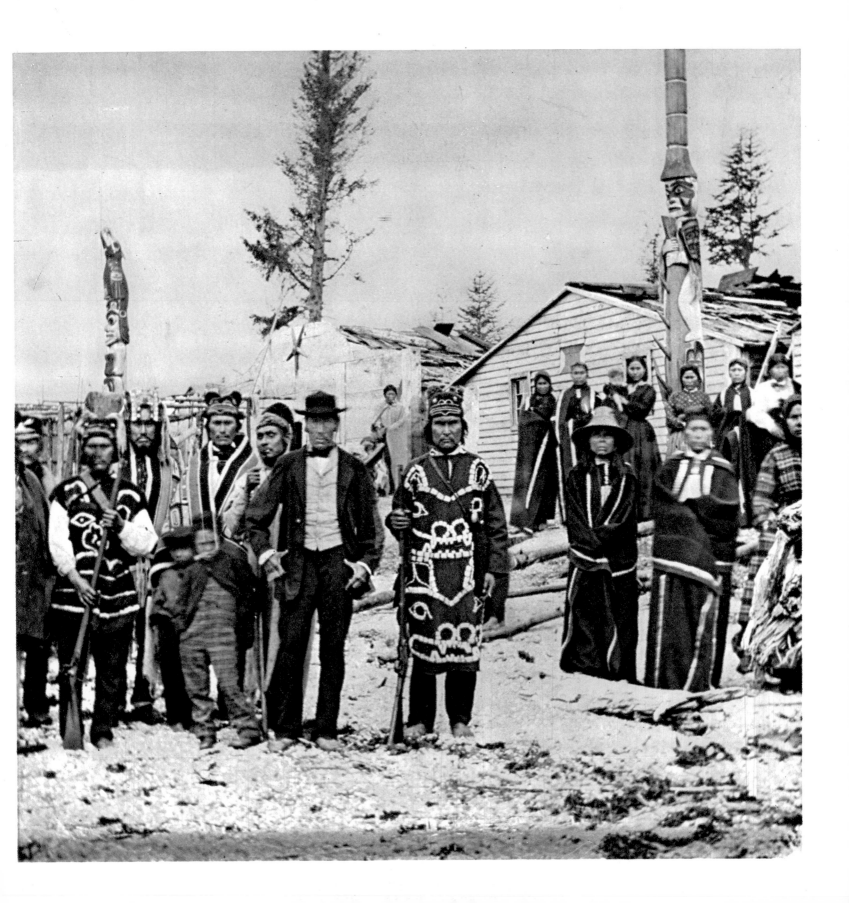

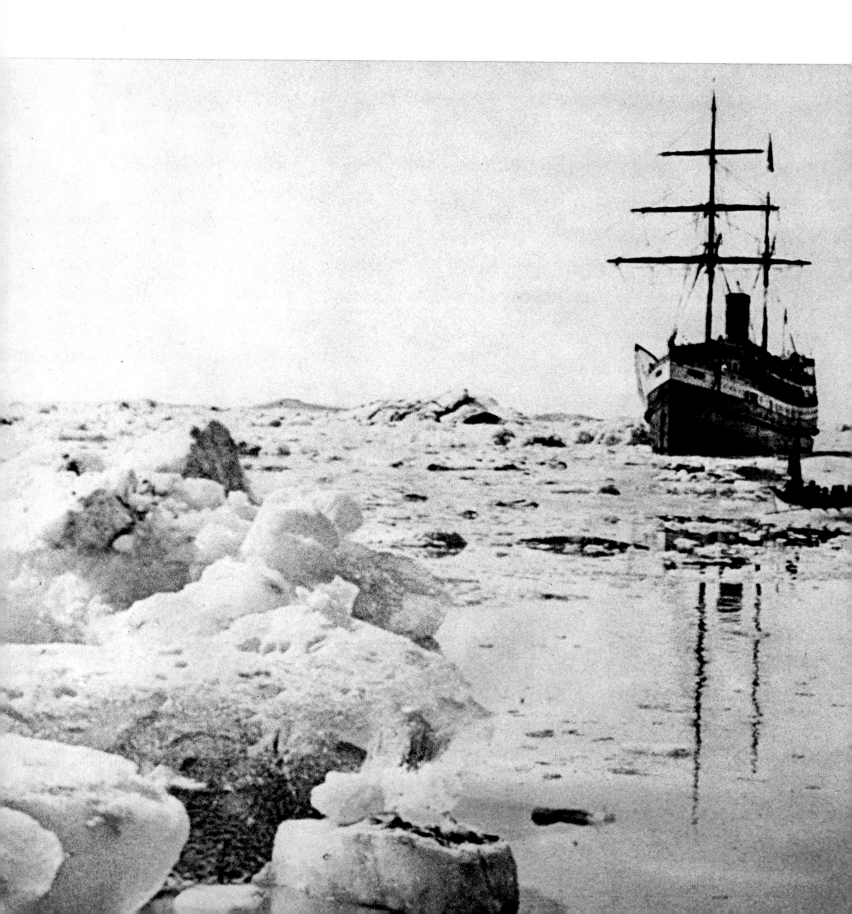

The steamer *Queen* in Glacier Bay, Alaska, with whalers in the foreground.

44

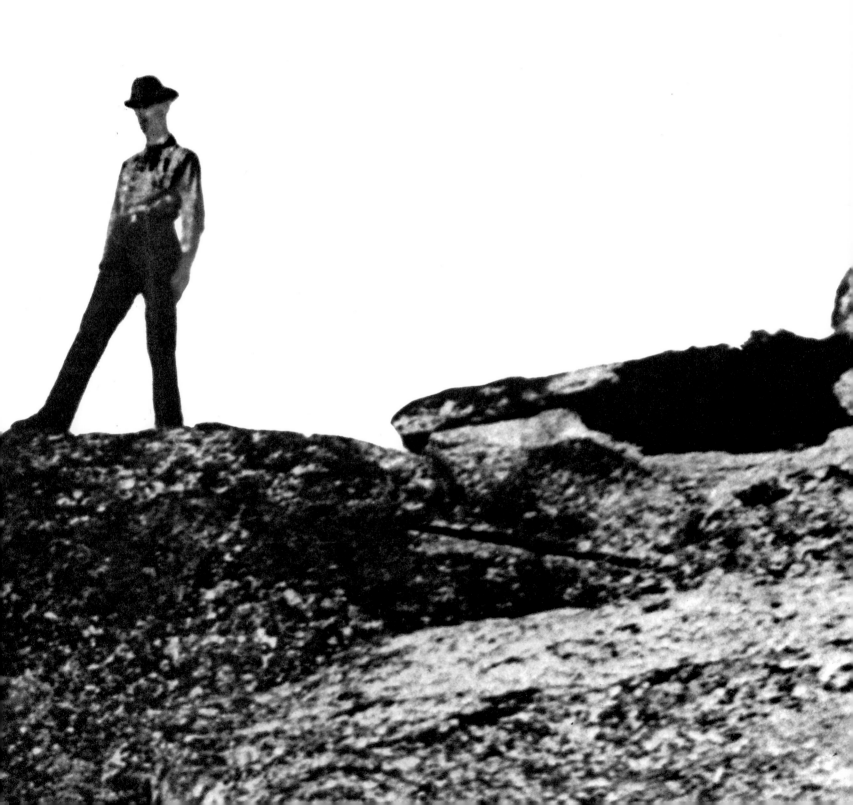

2 The Yosemite Valley

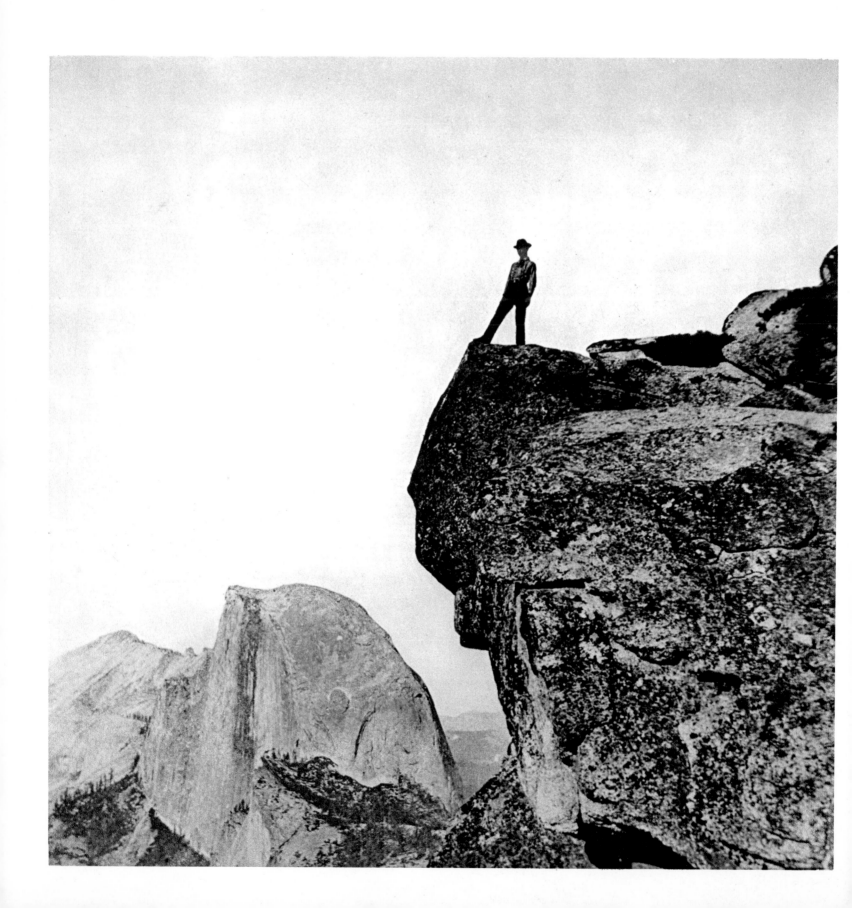

Left The end of Glacier Point,
Yosemite Valley. This is a wet
collodion picture, and must be one
of the first taken in this area.
Right The opening up of the
Yosemite Valley. A bespectacled and
straw-hatted tourist, accompanied
by his wife, is driven through an
arch cut through a living sequoia.

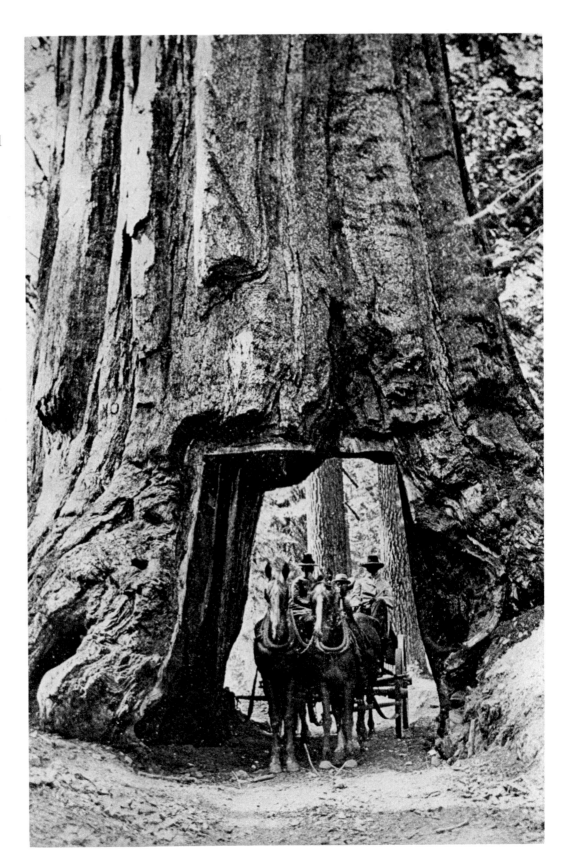

An early wet plate picture of what was then a deserted valley of staggering natural beauty. The waterfalls and the pine trees are still there but much of the solitude has departed.

No. 7827 Yosemite Valley. General view of the Yosemi

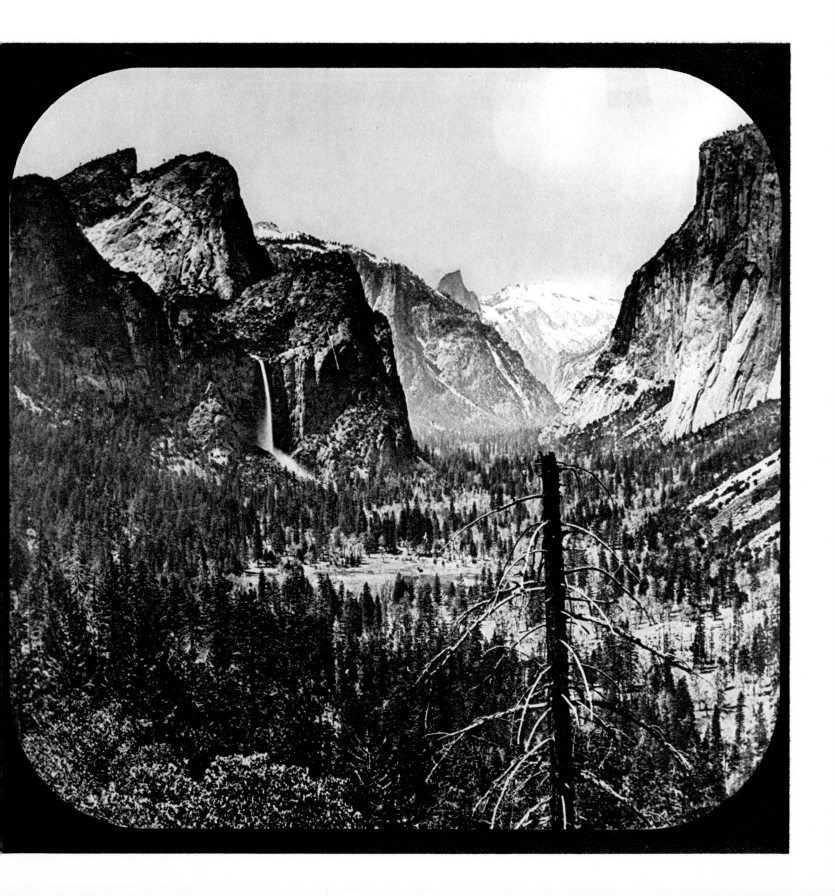

3 The Modoc War

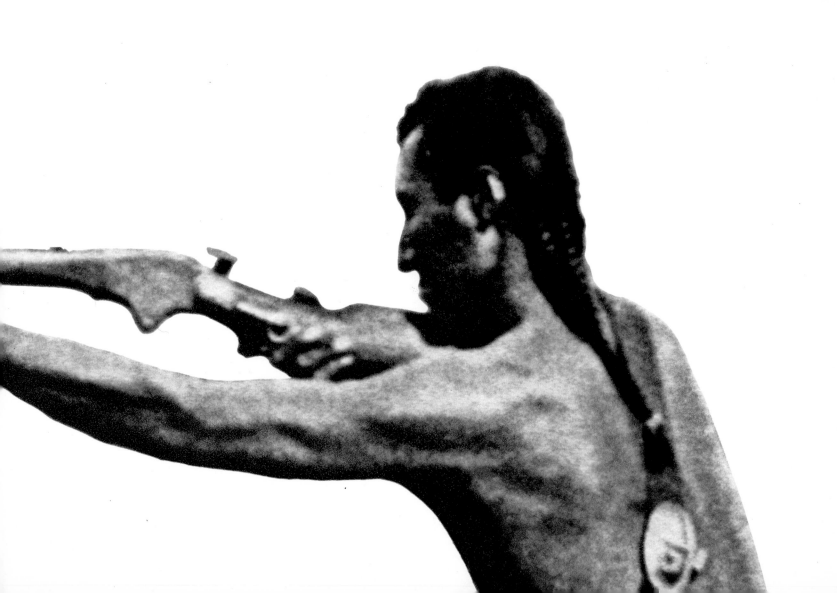

Donald McKye, an Indian scout, is
armed with a single shot, breech-
loading Sharps carbine, an extremely
accurate weapon which gave rise to
the word 'sharpshooter'.
Right 'A Modoc Warrior on the War
Path.'

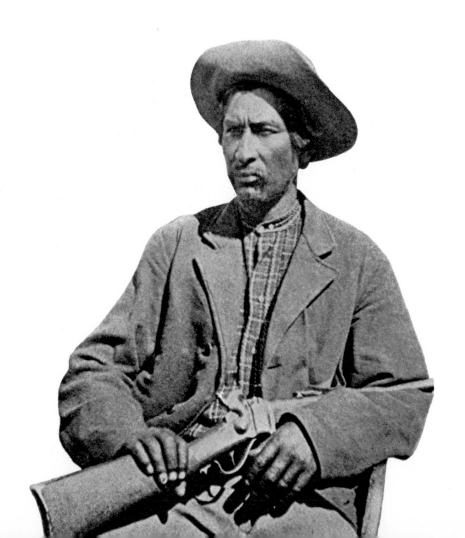

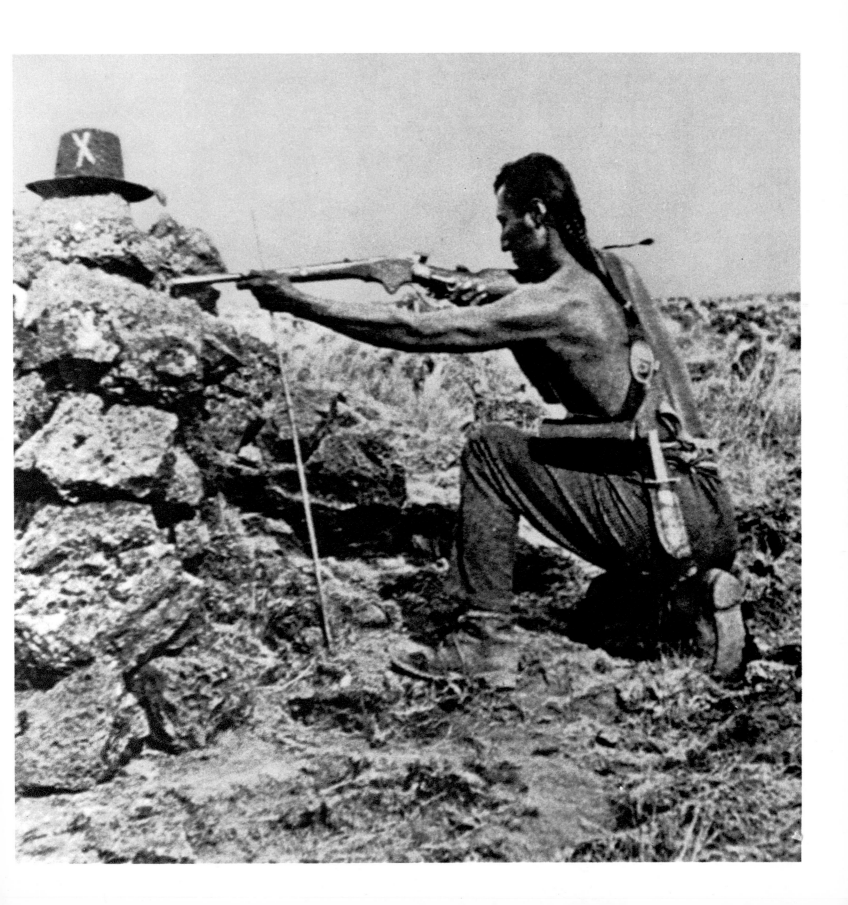

'A Modoc Warrior on the War Path.'
Right Indian scouts, dressed in pieces
of cast-off U.S. cavalry uniform and
carrying muzzle-loading rifles.

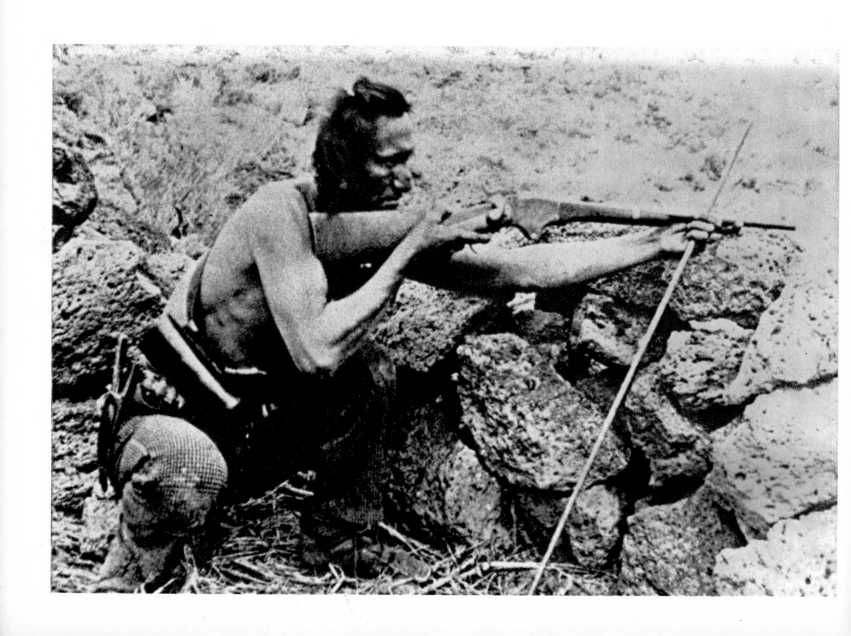

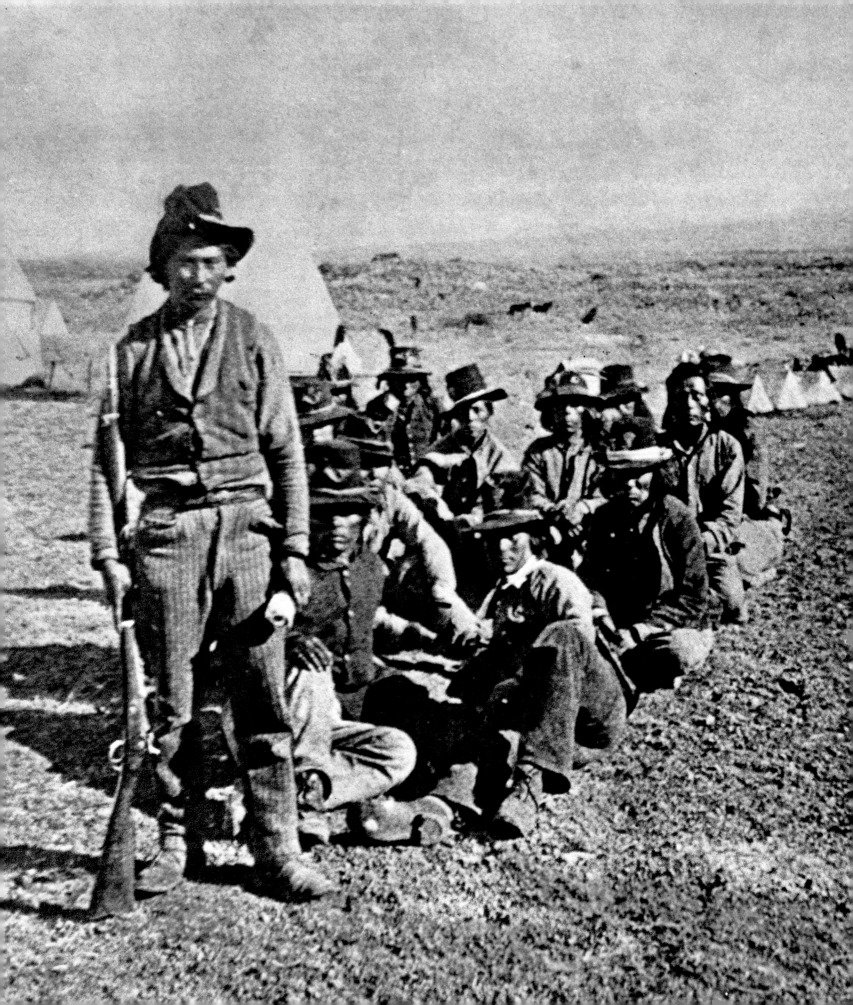

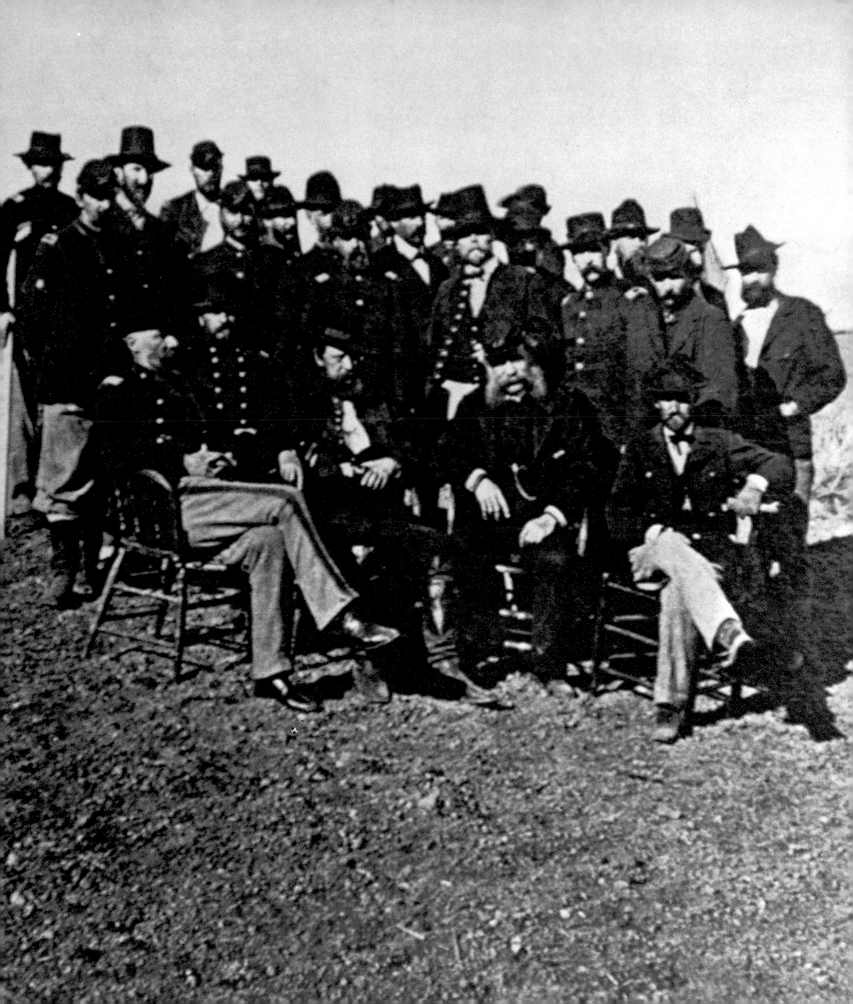

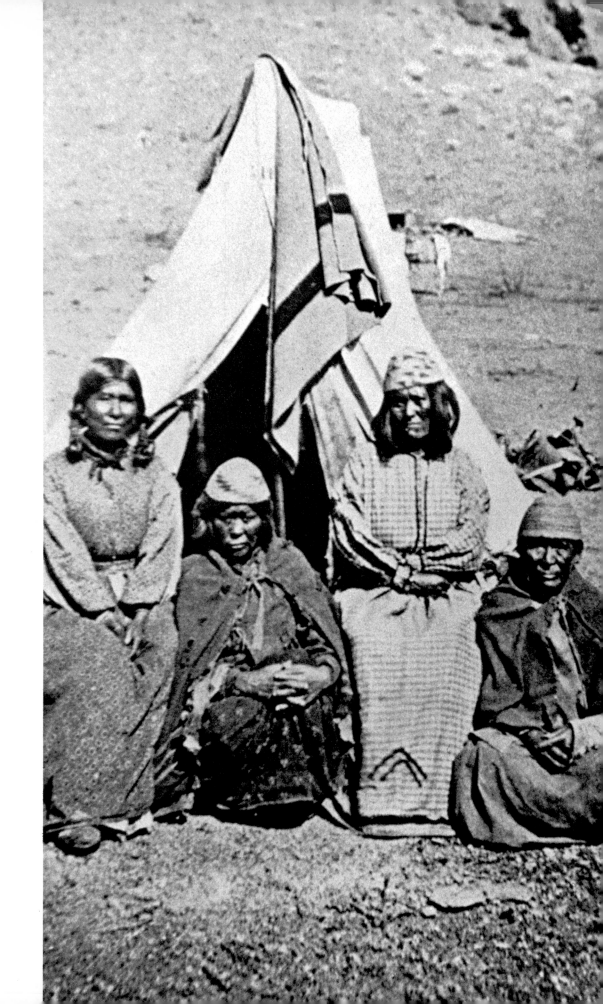

Left 'Generals Davis, Hardie, Gillem and officers of the Modoc Campaign.'
Right 'One-Eyed Dixie and other Modoc squaws.'

Below 'Warm Spring Indian Scouts
in Camp.'
Right Muybridge beside a small
stone fort. This may be the earliest
known photograph of the photo-
grapher himself.

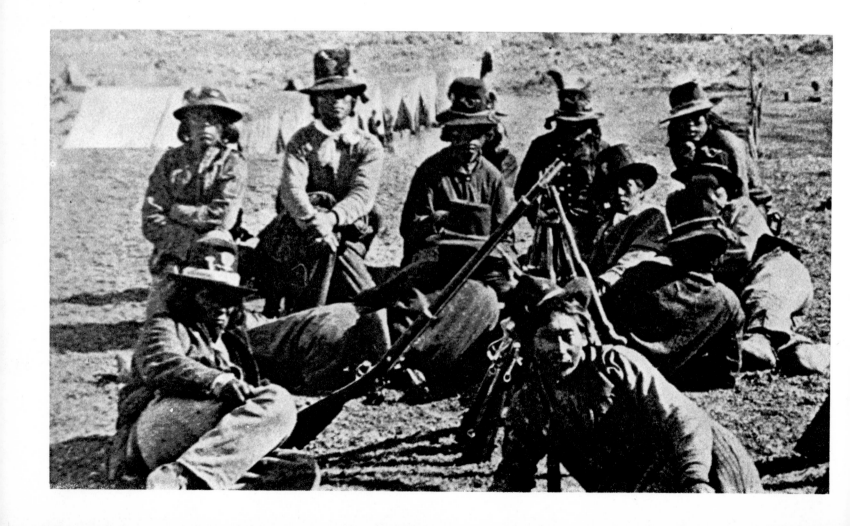

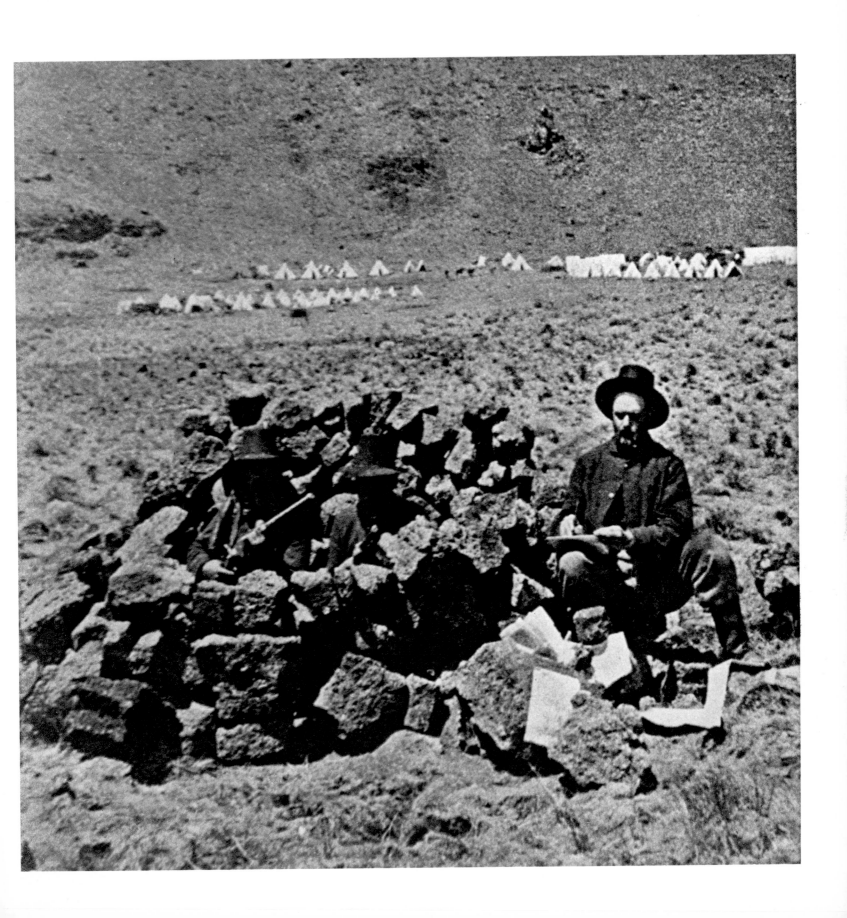

4 Central America

A shoot in Old Panama. The party carry early breech-loading shotguns and are obviously from the city.

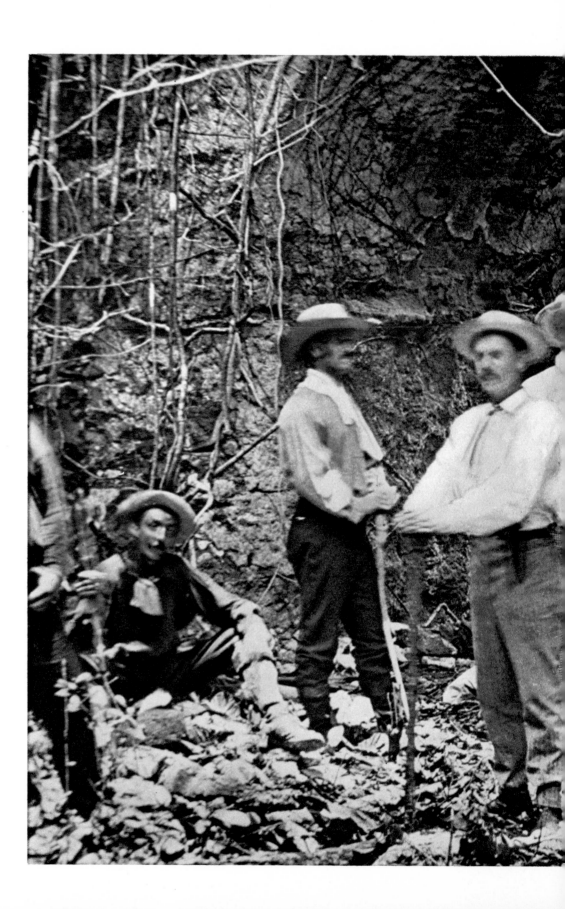

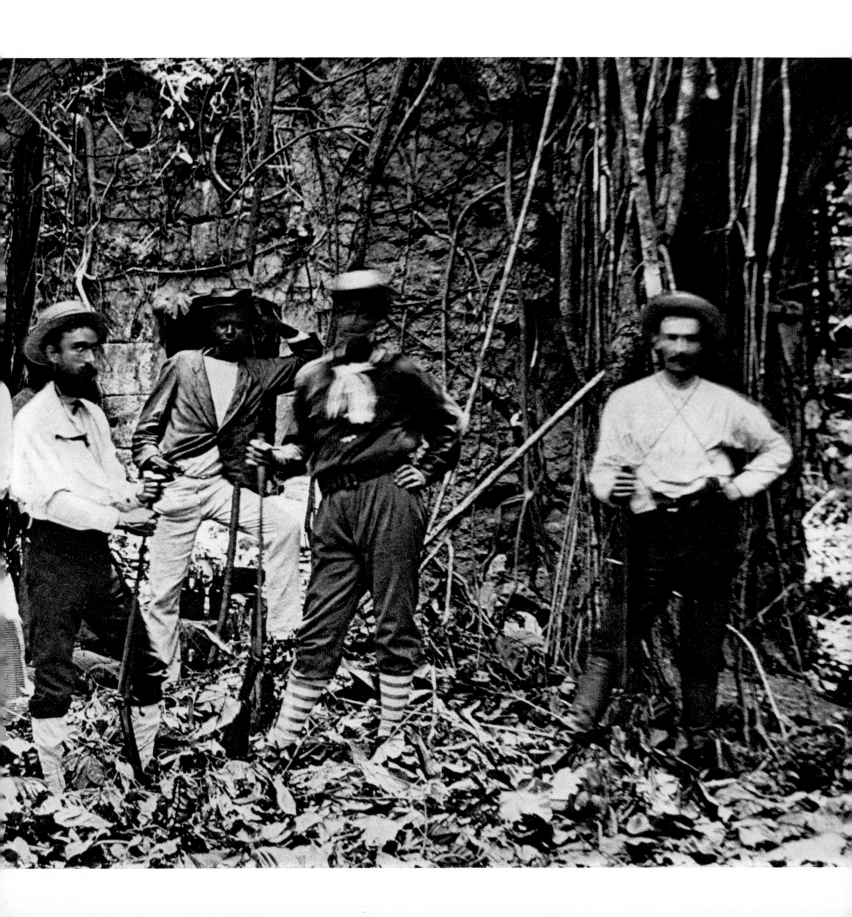

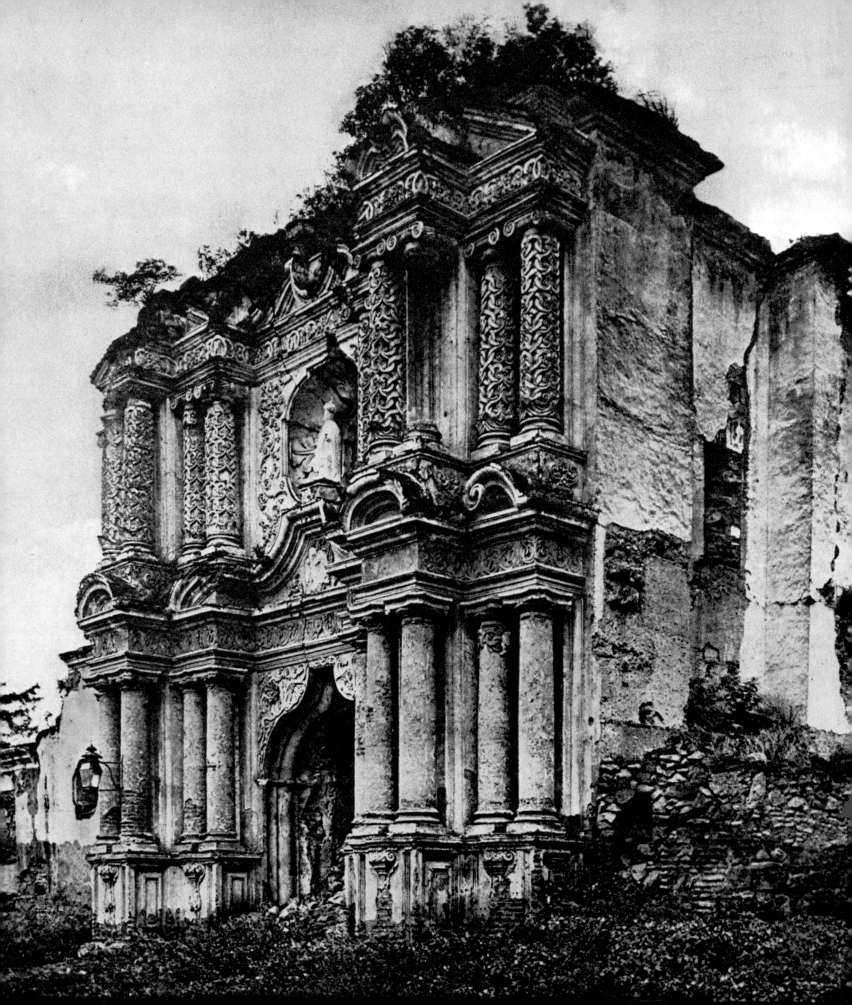

Left A shattered, overgrown cathedral in Old Panama City, wrecked by earthquakes. It lies about six miles up the coast from the modern city.

Right The almost equally ornate National Bank. Two armed guards sit at the entrance to the courtyard, in which stands a fountain, while an oil lamp provides street lighting. In both cases Muybridge has printed in the sky from a separate negative. The quality he could obtain on wet plate is quite extraordinary.

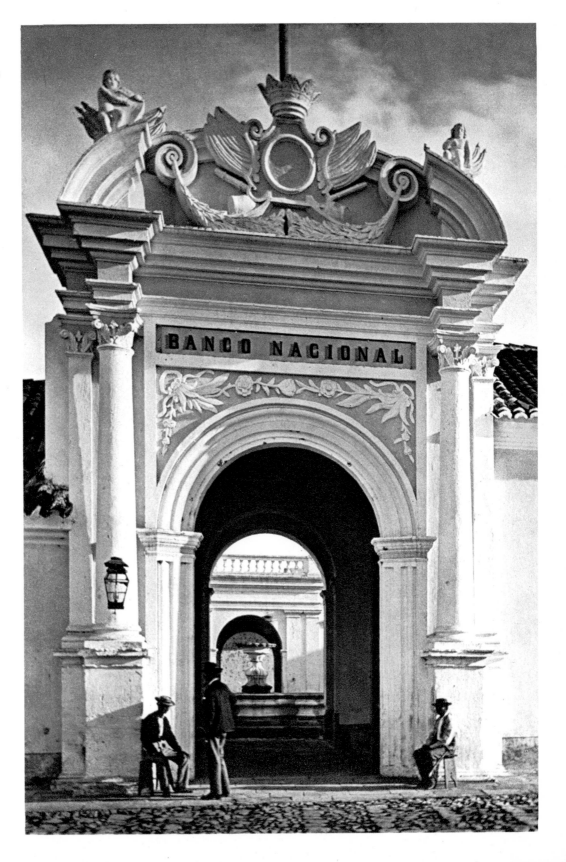

5 November 1875. The Army of
Panama parades in the Cathedral
Plaza. The officers stand with drawn
swords in the foreground while the
band plays and the National troops
sweat in the midday sun. From left
to right the heavy armament consists
of a small field gun, a brass mortar,
a Gatling gun (one of the first
machine guns) and another field gun.

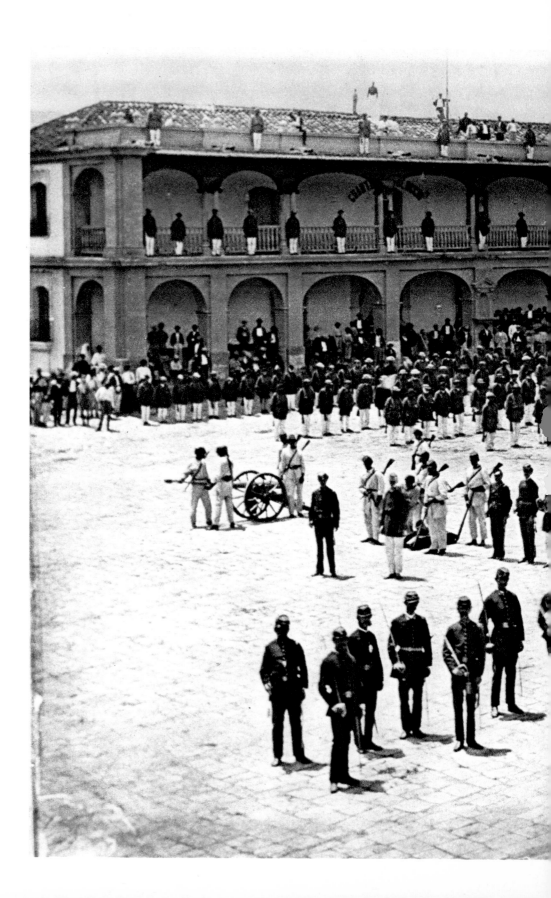

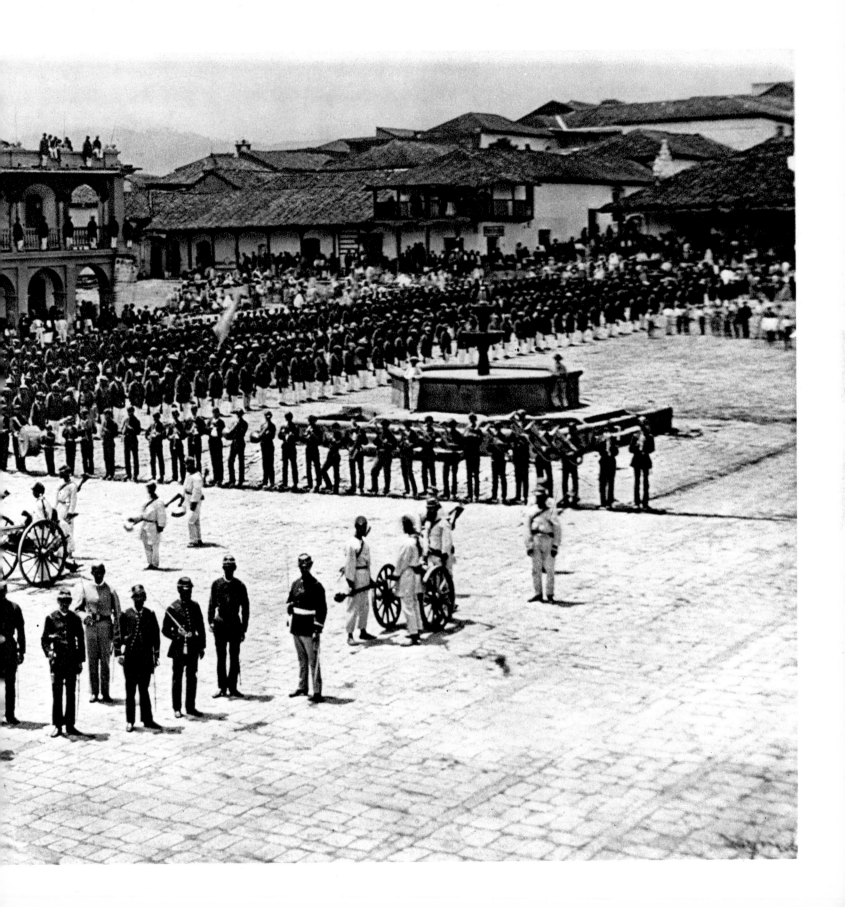

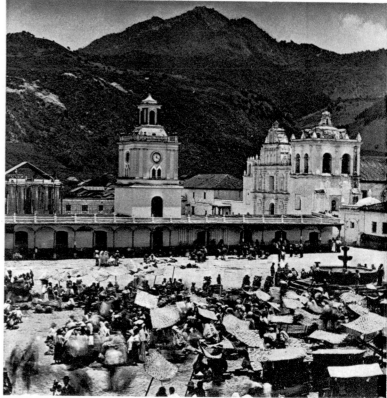

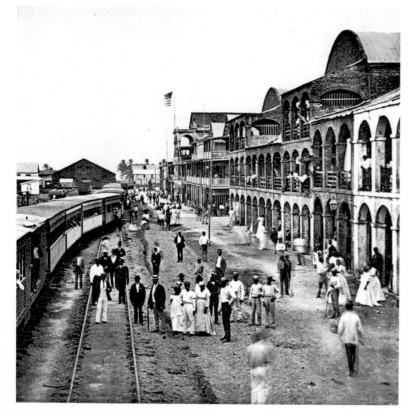

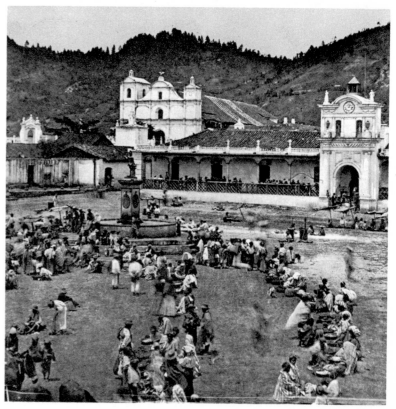

Central America.
Far left, top A mill for grinding
sugar cane.
Bottom left Panama City Station,
with the American flag flying and in
the background, behind a statue,
a factory for making ice.
Top centre 12.20 a.m. on market
day; matting provides some shade.
Bottom centre Another town, another
market. The classic statue over the
fountain seems incongruous. In both
cases the exposure was about a
quarter of a second on wet collodion.
Left The traditional costume of the
Guatemalan Indians contrasts with
the cross and the Baroque church.

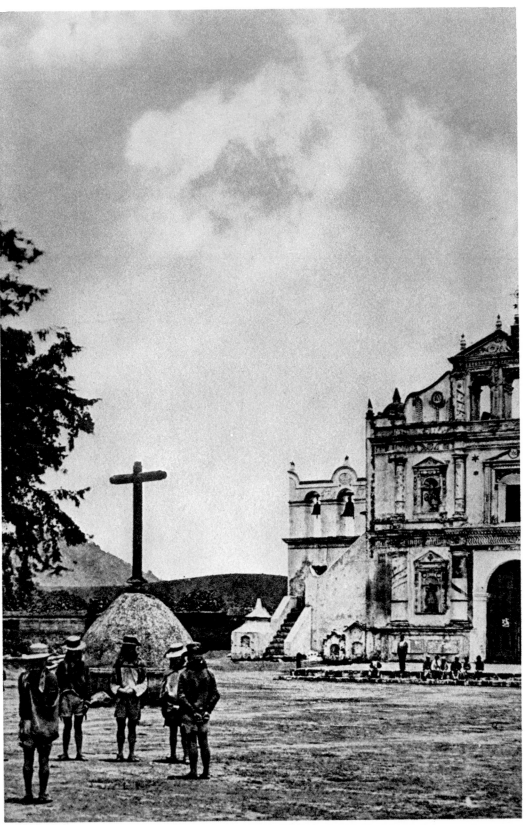

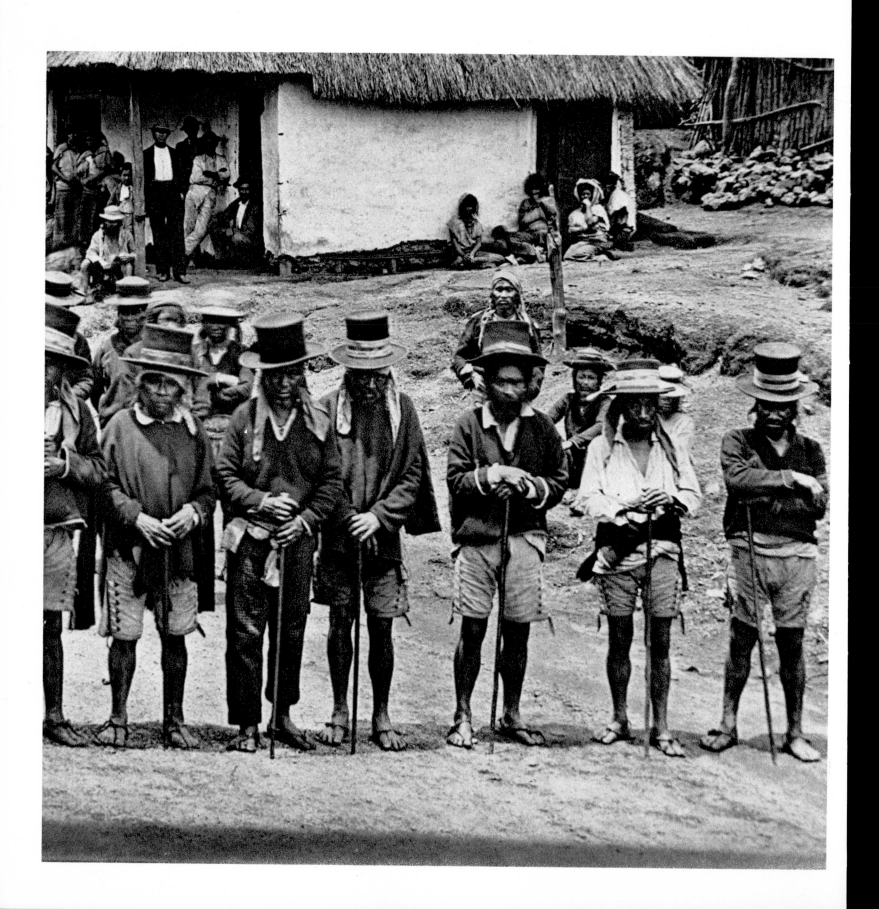

Right Guatemala. The barefoot
soldiers are armed with ex-U.S. Civil
War Enfield ·577 rifles, but do not
seem to have any ammunition
pouches.
Left The other picture shows villagers
unblessed by civilization.

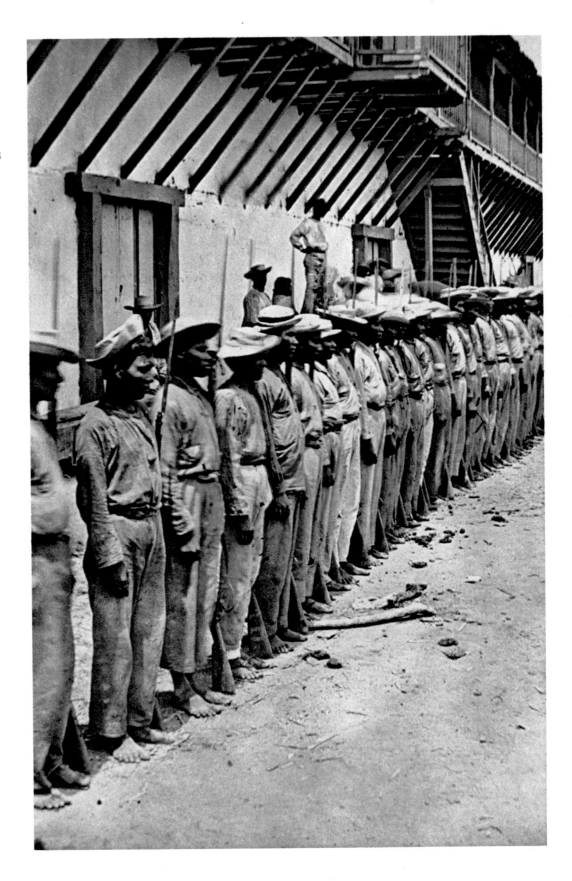

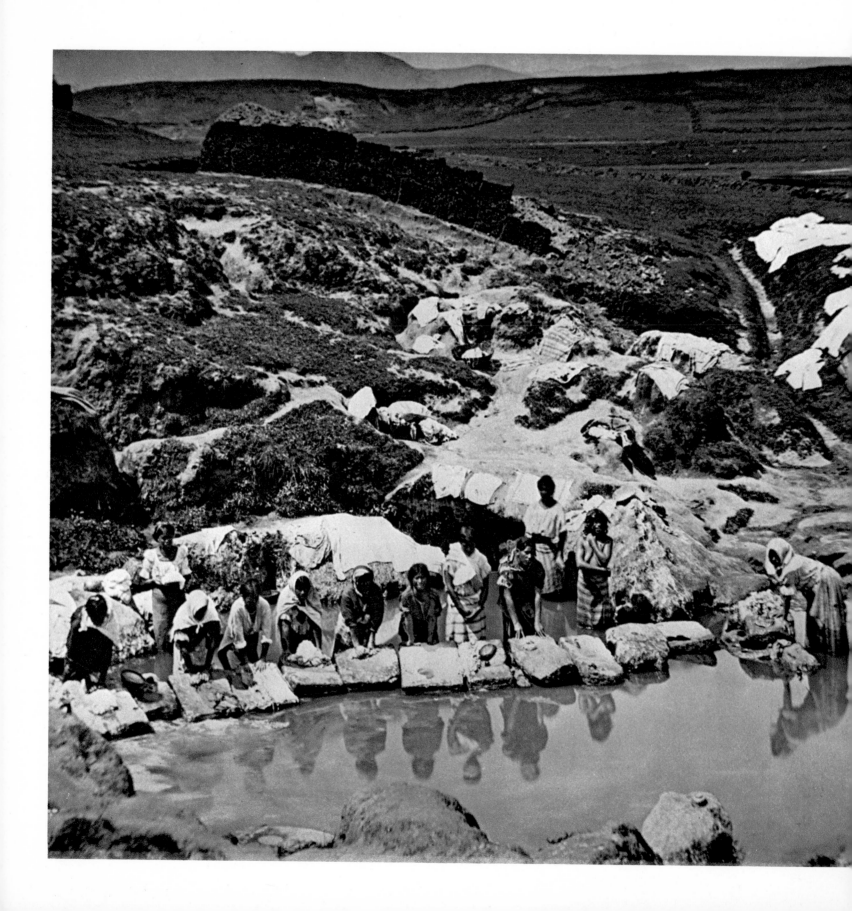

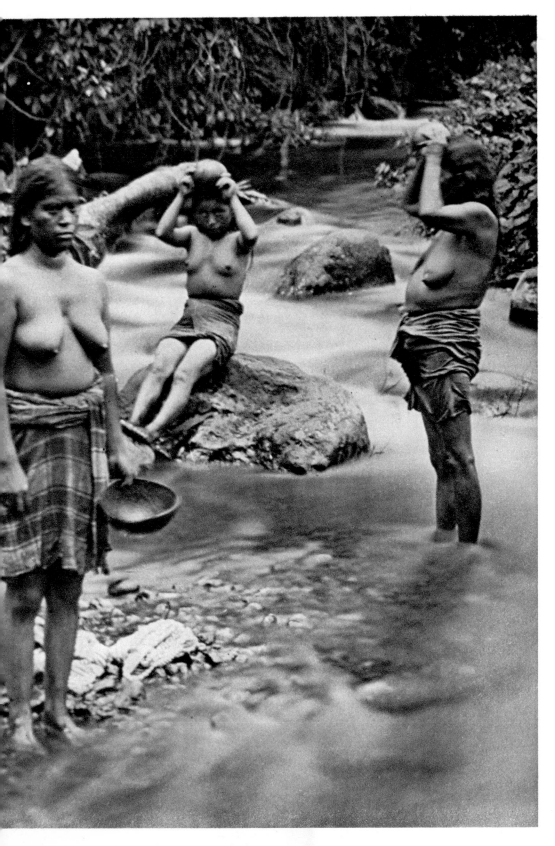

It is hard to realize the difficulties of taking these pictures in Guatemala in 1875. The glass plates had to be coated with collodion (gun-cotton dissolved in ether) on the spot and exposed and developed before the heat could dry them. A darkroom tent was essential, as was a sturdy tripod for the huge wooden camera. The right-hand picture was taken in dull light and the plate must have been exposed for several seconds.

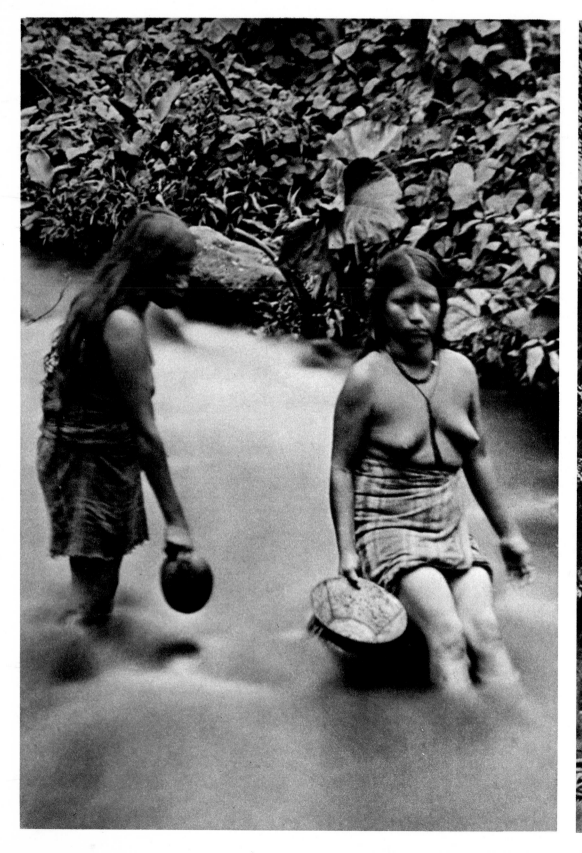

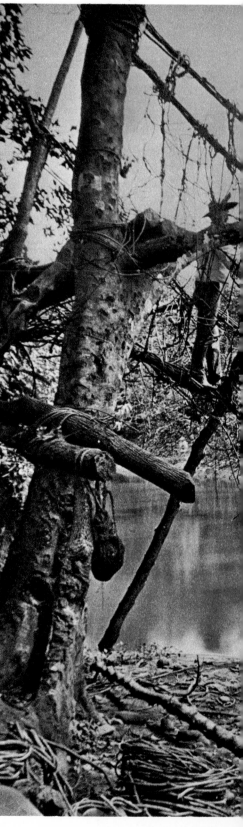

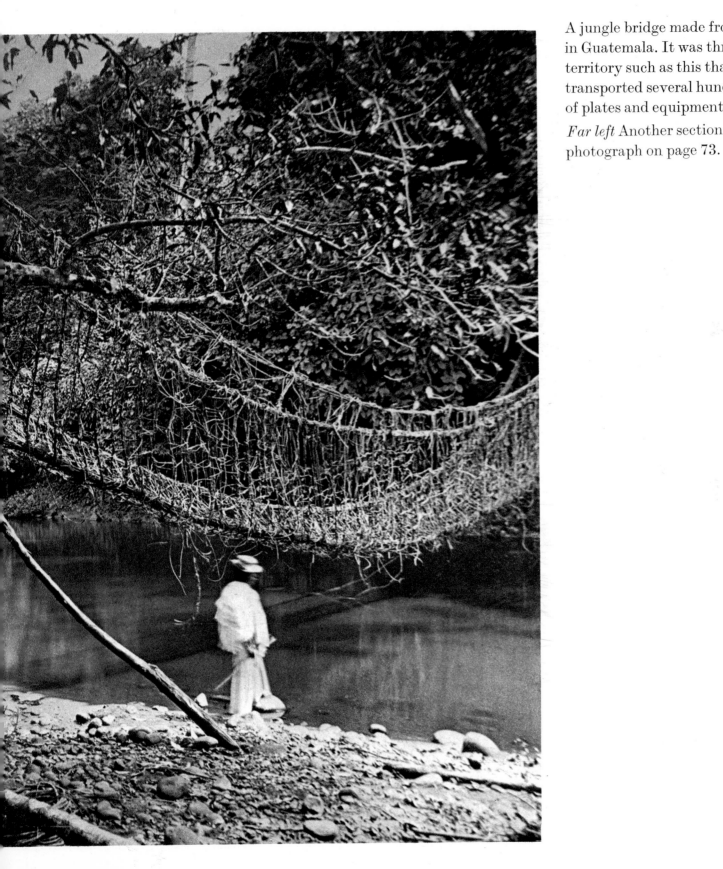

A jungle bridge made from creepers in Guatemala. It was through territory such as this that Muybridge transported several hundredweight of plates and equipment.

Far left Another section of the photograph on page 73.

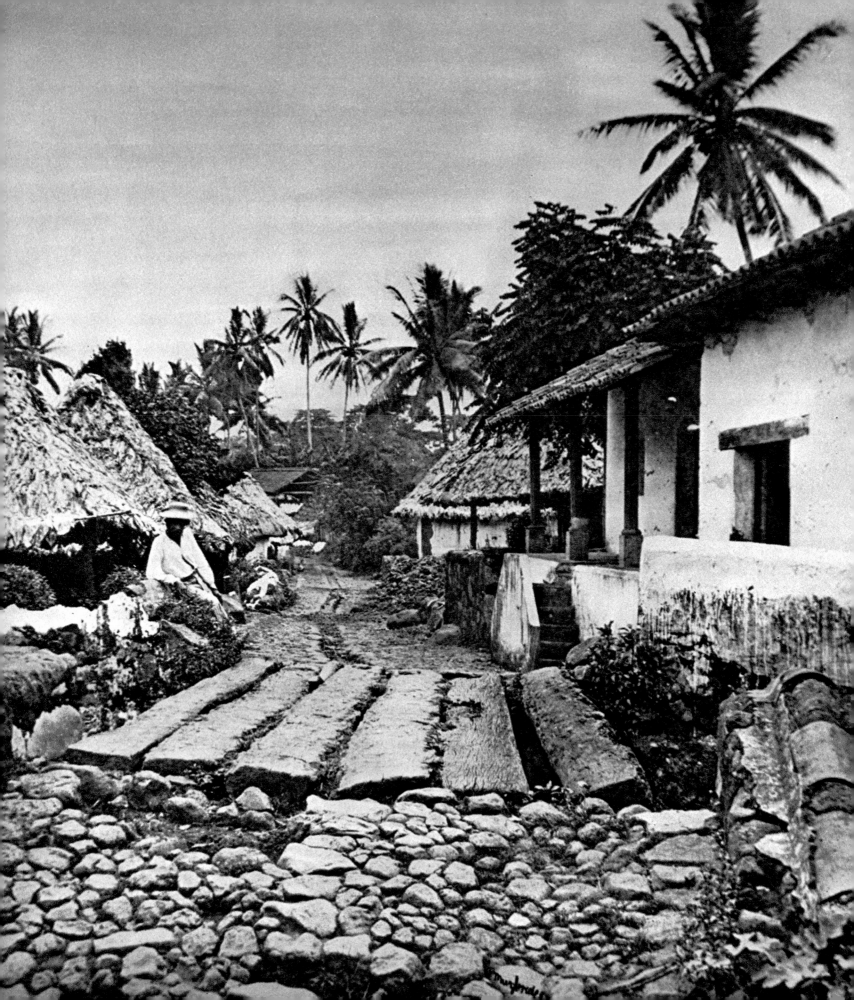

Left A village street.
Right Muybridge's attempt at printing in a sky from another negative did not quite succeed. Bullock carts are drawing into the yard while fishing nets hang drying on the walls.

Peasant family before its hut.

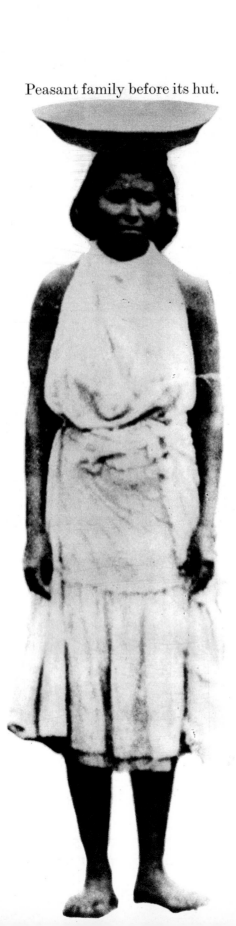

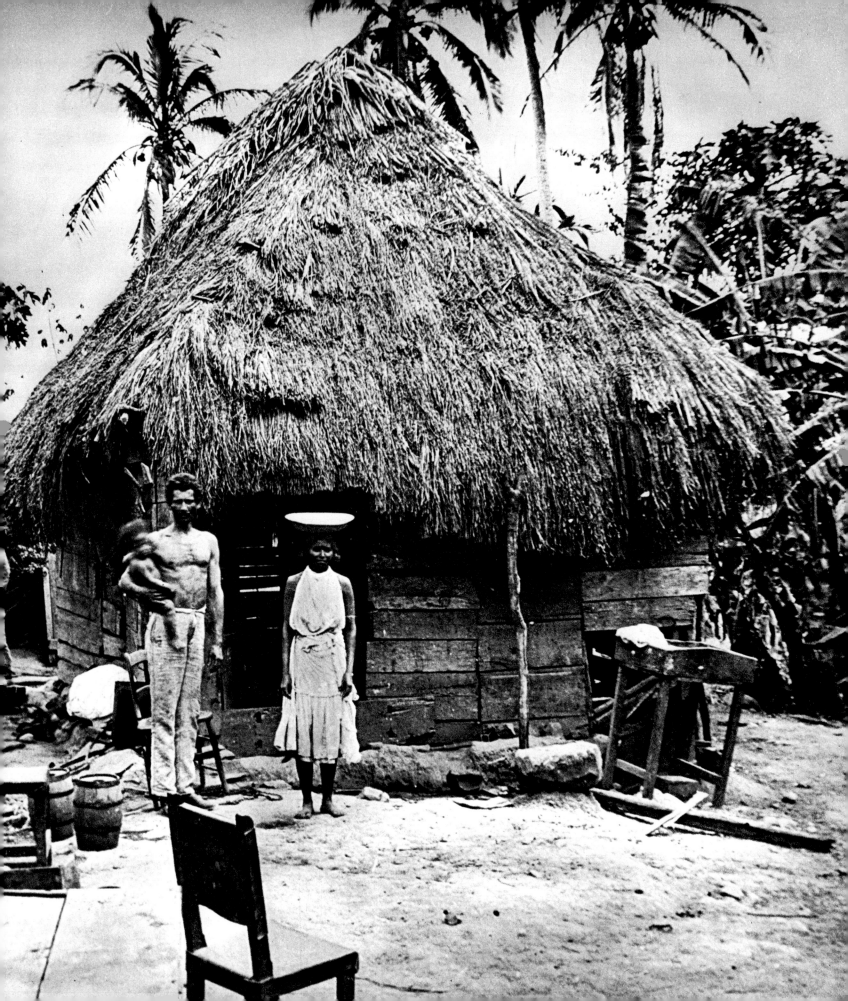

5 Palo Alto

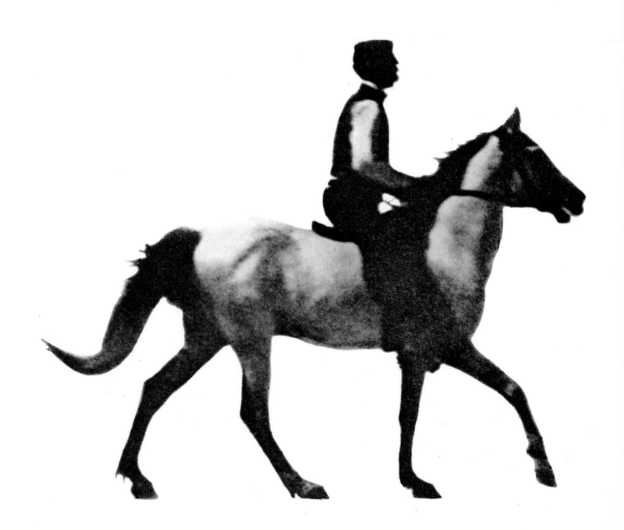

The face Leland Stanford presented to the world was that of a tough and ruthless man of business; the cultured romantic lurked just below the surface. Muybridge, on the other hand, seemed artistic and unworldly, but managed to earn huge sums with his camera.

Far right Muybridge, wearing his usual big black hat, was probably photographed at Pennsylvania University.

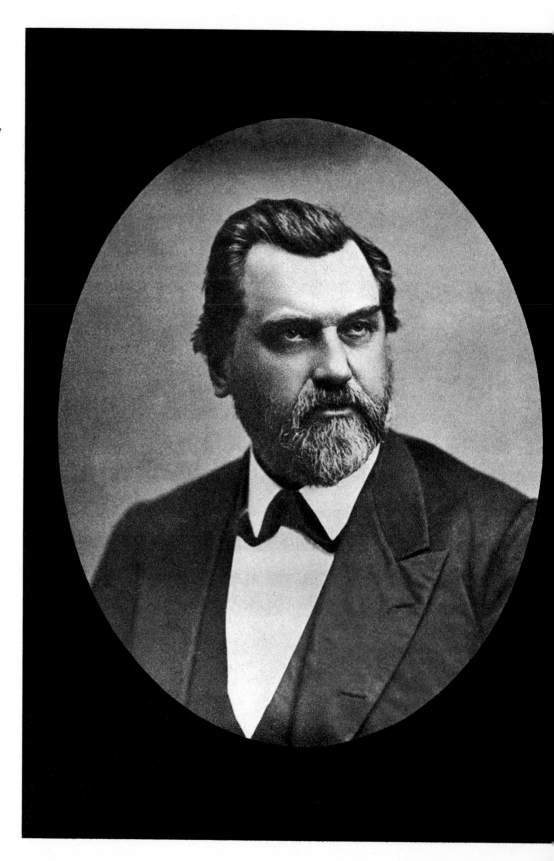

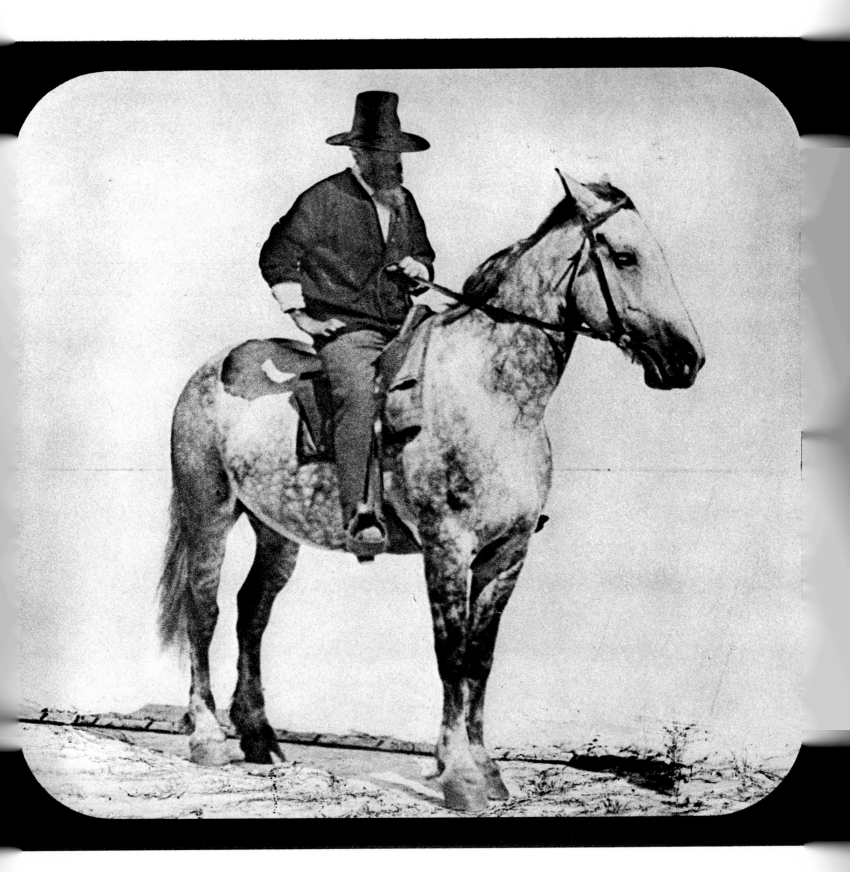

Top right The track at Palo Alto, designed to obtain the maximum amount of reflected light.
Bottom right Three cameras working at three different angles are being used. Large, slanting white screens throw light towards the subject.
Top centre The slit in the shutter ran down in front of the lens, a method of working now known to be highly inefficient.
Centre Rear view of the shutter mechanism. The blades were tensioned by stretching strong rubber bands attached to the cords and rings that can be seen. A catch held the shutter blade in place until it was released by the action of an electro-magnet, the same basic technique used in modern 'electronic' shutters.
Bottom centre Front view of camera showing the thirteen matched Dallmeyer lenses, the right-hand one being used for viewing and focusing.
Far right top Circuit of timing apparatus.
Far right bottom The timing mechanism, now in the Smithsonian Institute.

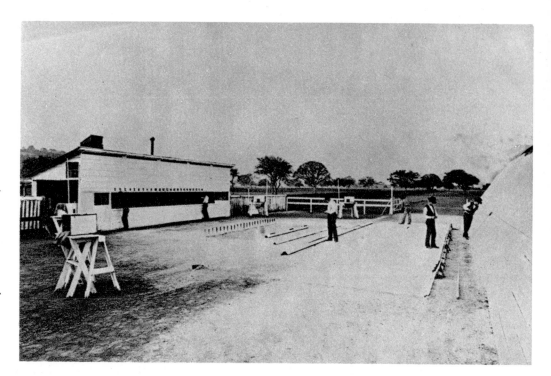

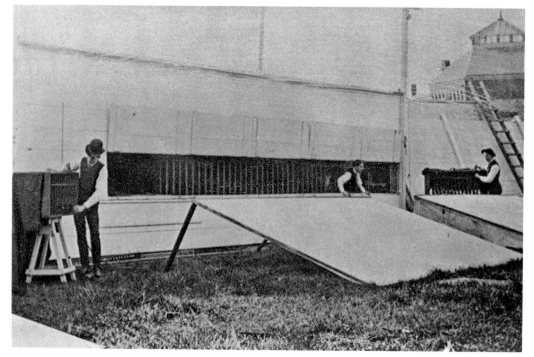

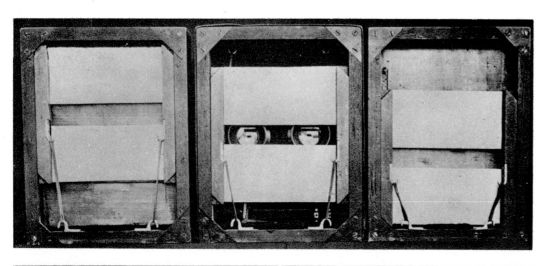

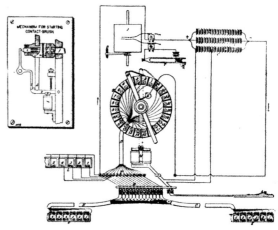

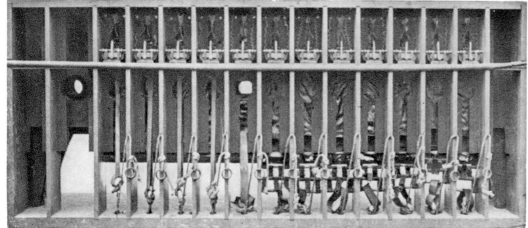

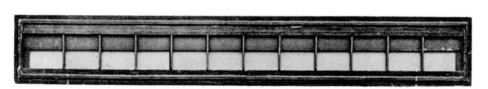

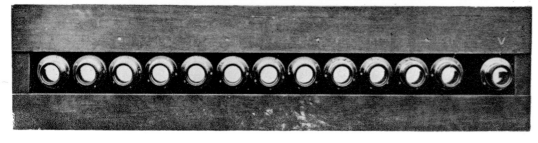

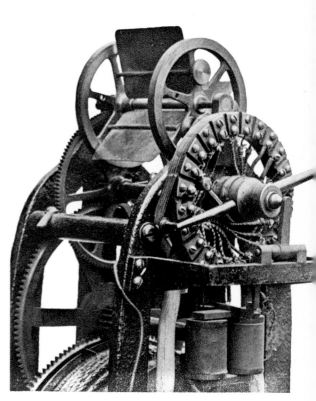

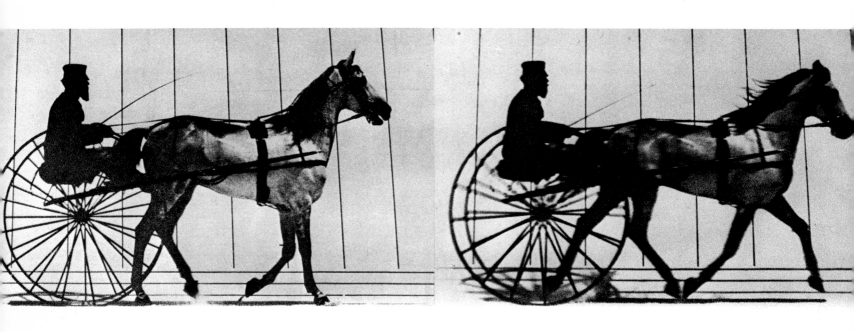

This is a composite of pictures taken at different times. The first, 'Walk', was taken in 1877. Since the horse was moving comparatively slowly, the exposure could be lengthened to perhaps 1/200th of a second and some tone and detail could be recorded. As the horse speeds up the exposure has to be shortened and more and more detail is lost.

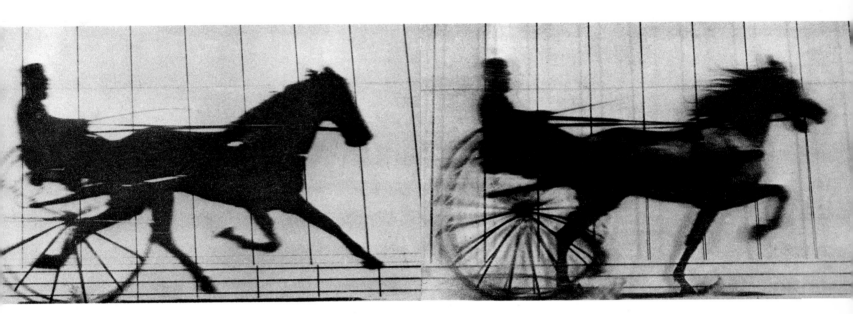

Muybridge has captioned the third picture 'Occident' and the last, taken in 1878, 'Edgington'. Both horses were famous trotters.

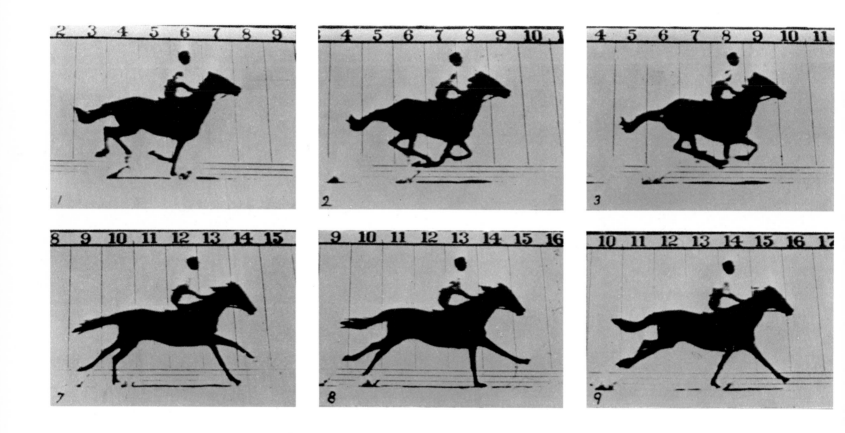

The wet collodion plates were far too slow to record anything but a silhouette at the shutter speed Muybridge was using, perhaps 1/750th of a second. The negatives were hopelessly underexposed, but by intensifying them, probably with mercuric chloride, a printable result was obtained.

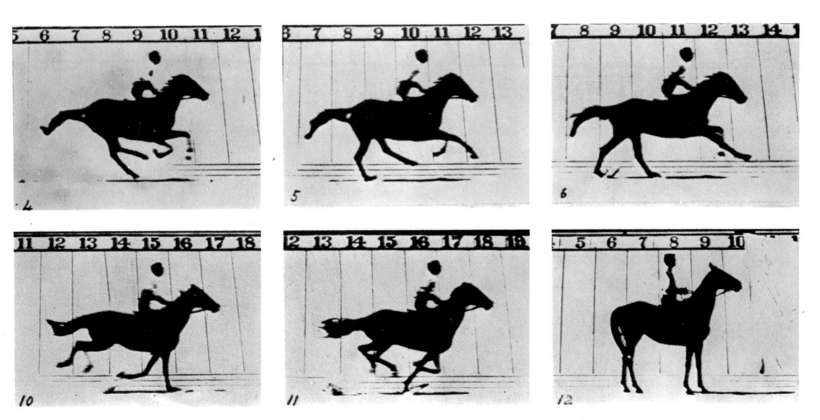

Overleaf Detail of a page from Muybridge's scrap-book describing a horse's movements.

Jake backed his horse, sn
the stool. Then when he had
he uttered a halloo, while
his heels into the sides of his st
x x n. He-urued seem as the
feelings that actuated their n
snorted defiance, they tossed
and pawed the air.

the curb

...ing and plunging asunder,

...tered some twenty yards,

...is flare above his head, draw...

..., and came on at a gallop.

...the horses understood the

...es, and shared them. They

...heir manes, they reared

Panoramic view of San Francisco,
taken from the tower on top of Mark
Hopkins's house.

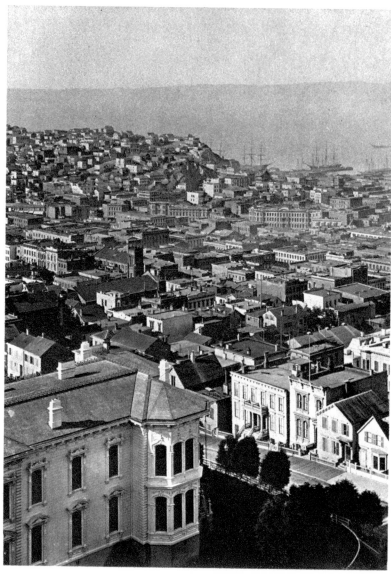

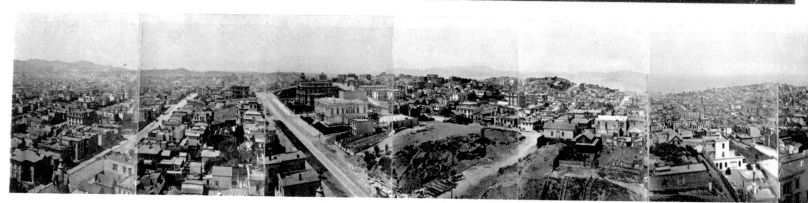

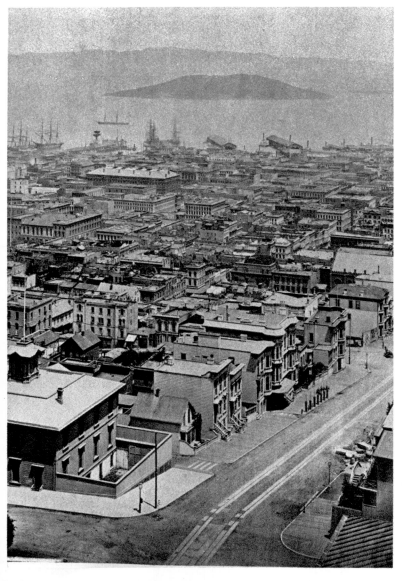

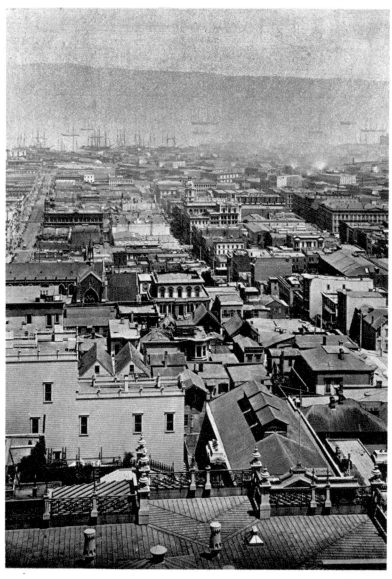

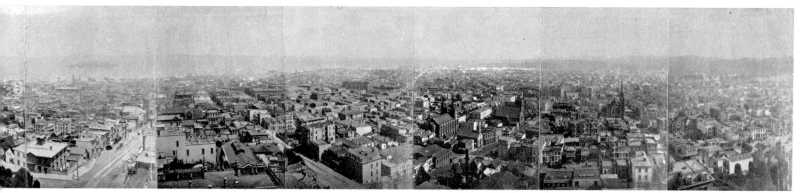

6 Other travels

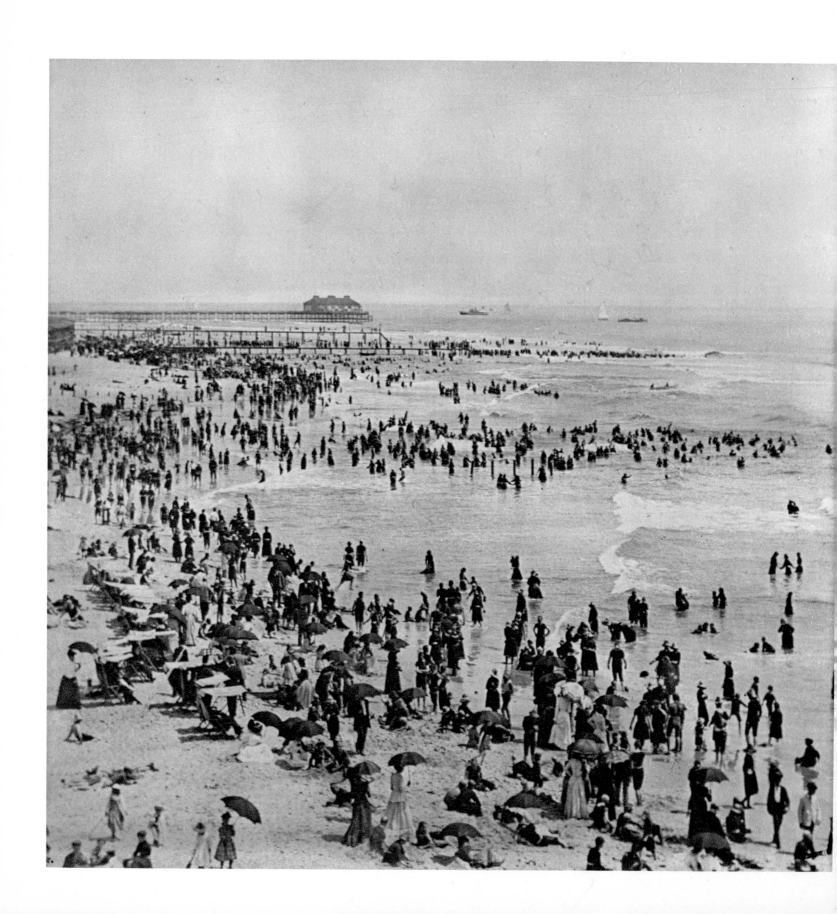

Atlantic City, New York's playground in the 1880s. Muybridge was taking candid camera pictures years before Paul Martin.

The stern wheel riverboat *Louisiana* loading at New Orleans. Note the huge lights and the inverted lucky horse shoe.
Far right: Top First trials of the U.S. cruiser *New York*.
Bottom left The landing stage, New Orleans.
Bottom right The Chicago World Fair, 1895. Reproductions of Columbus's ships the *Nina* and the *Pinta*.
Overleaf A tourist coach in Yellowstone Park.

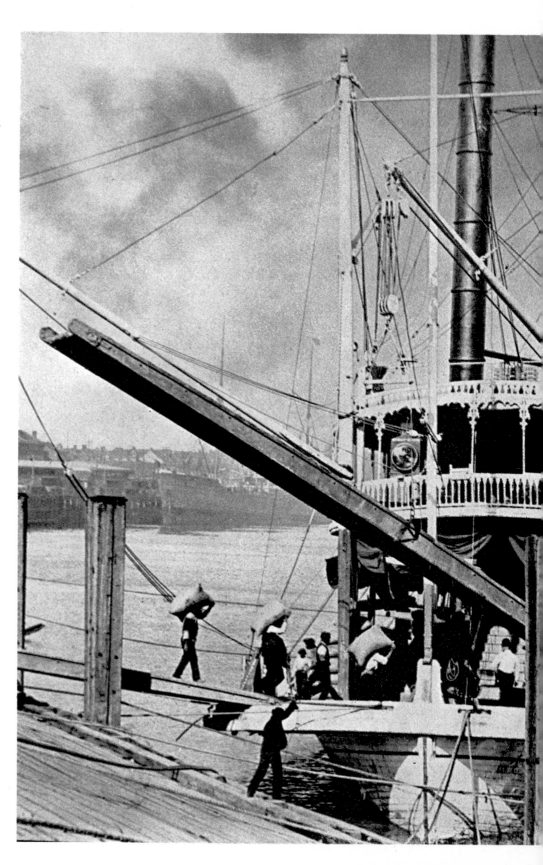

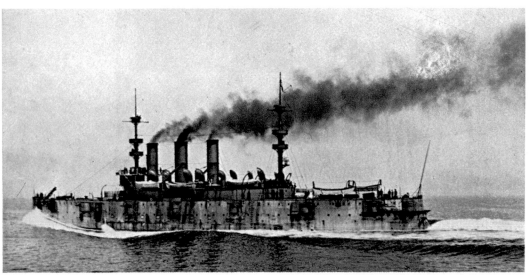

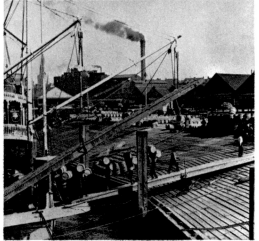

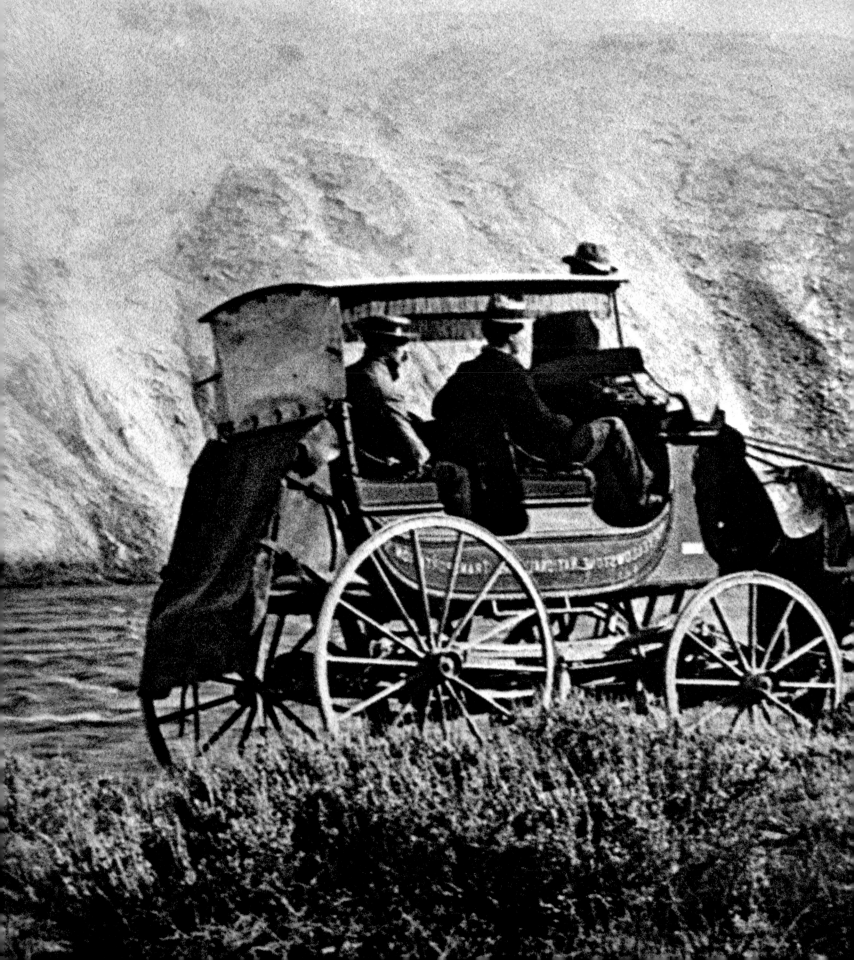

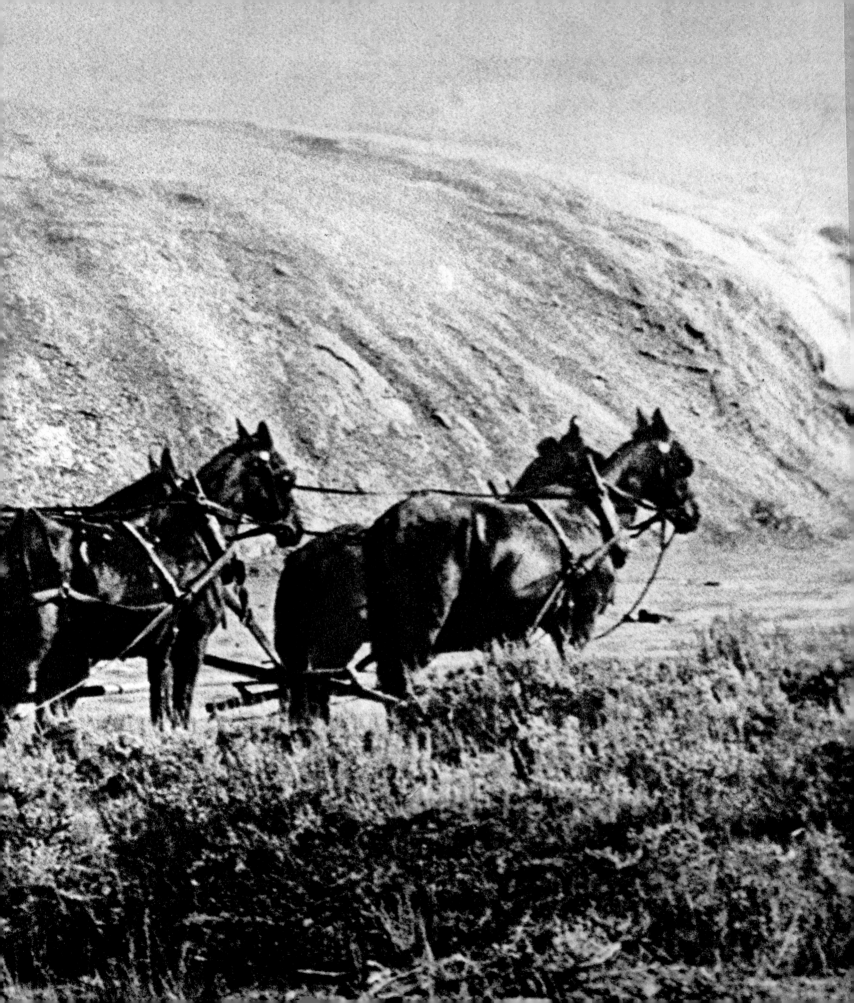

Top left The Indians did not know the wheel and heavy loads were strapped to two poles, called a *travois* and dragged across country behind a horse. This photograph was taken in the North-West Territory.

Bottom left An artist painting the Indians.

Top right No details are available of this superb picture of a herd of horses.

Bottom right The Green Mountain funicular railway, Bar Harbour, Maine.

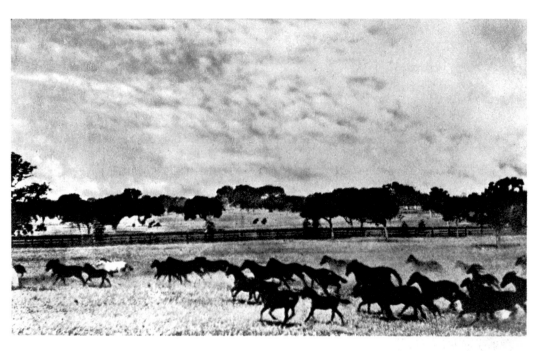

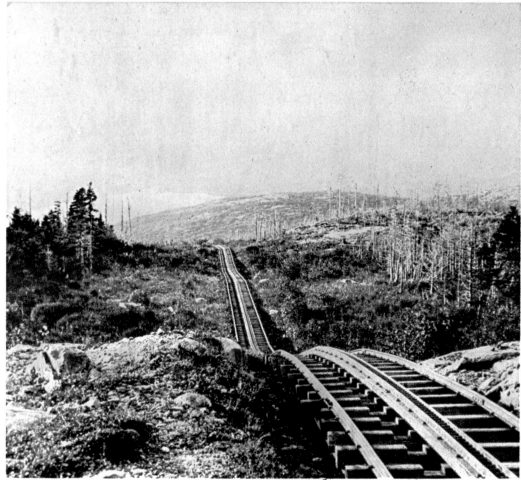

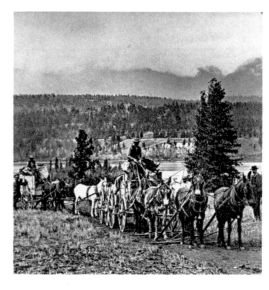

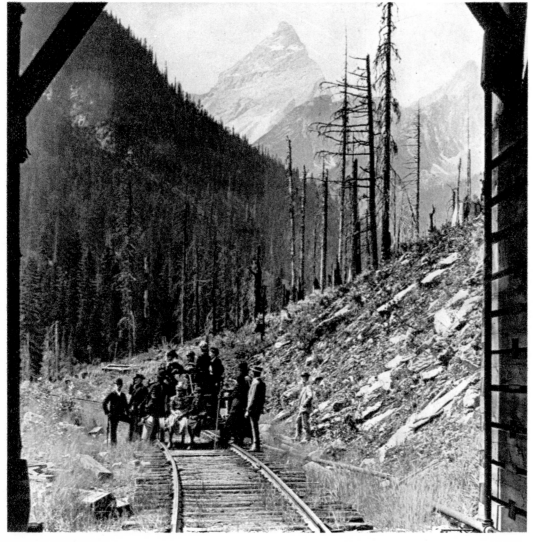

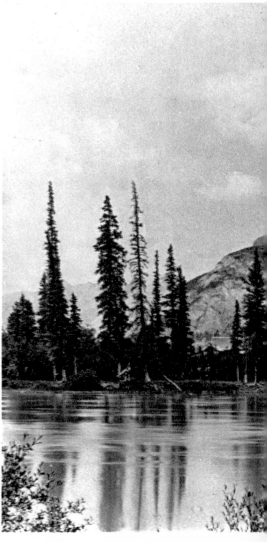

Left A mule train in Alberta.
Below: Left Muybridge's own caption
was 'Sir Donald from Snow Shed
No. 31. Alberta, Canada'.
Centre Cascade Mountain, Banff,
taken from across the Bow River.
Right Camping at Emerald Lake,
Alberta.

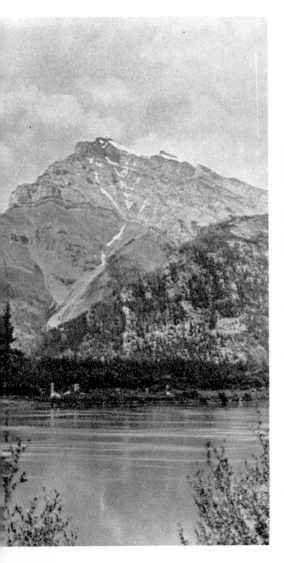

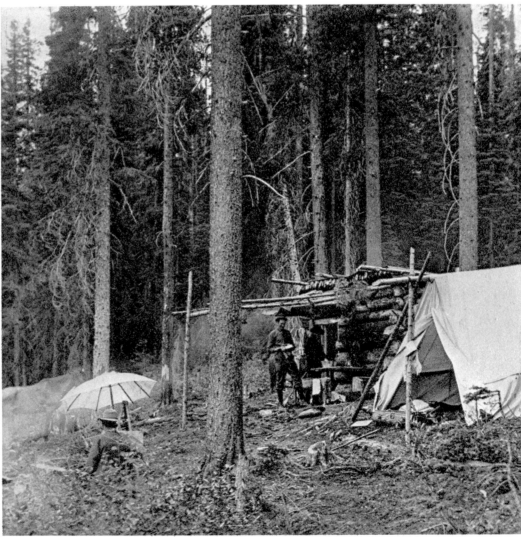

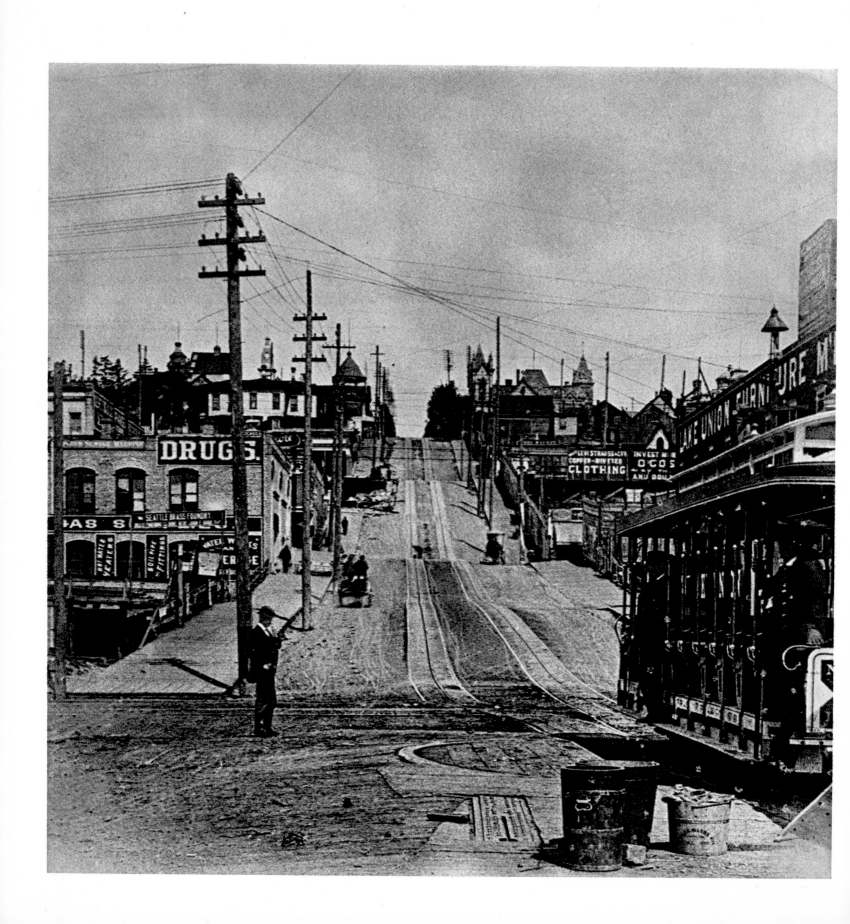

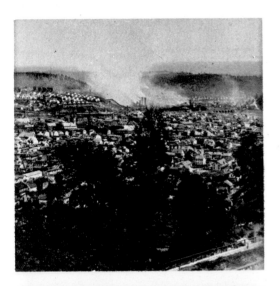

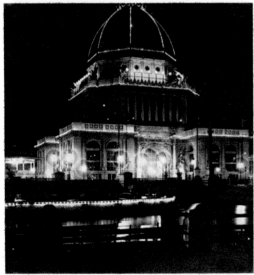

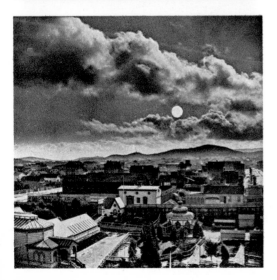

Far left San Francisco? A sign advertises the 'Seattle Brass Foundry'.
Left: Top 'Johnstown from Kernville Hill.'
Centre 'The Administrative Building. Night Illumination.'
Bottom A 'moonlight' picture. The clouds and the landscape were taken on two separate negatives against the light in sunshine. They were then carefully matched in printing and the moon was added. This must be an early picture since the signature 'Helios' appears on one of the sails attached to the roundabout in the foreground. A sign may read 'Woodward Gardens'.

Top right 'Interior of reverse curve snow shed No. 24. Selkirks, Alberta, Canada.'
Bottom right A bullock cart at Thomasville, Georgia.
Far right Cattle branding in Assinboia, Alberta.

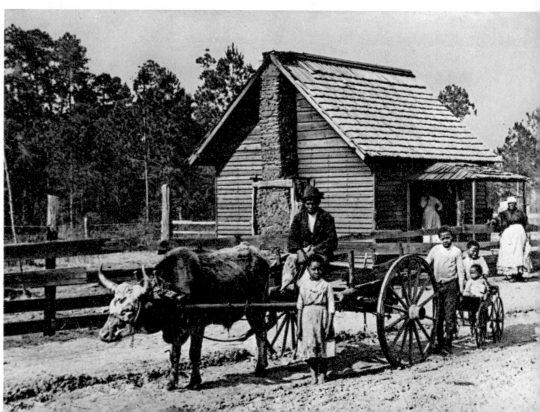

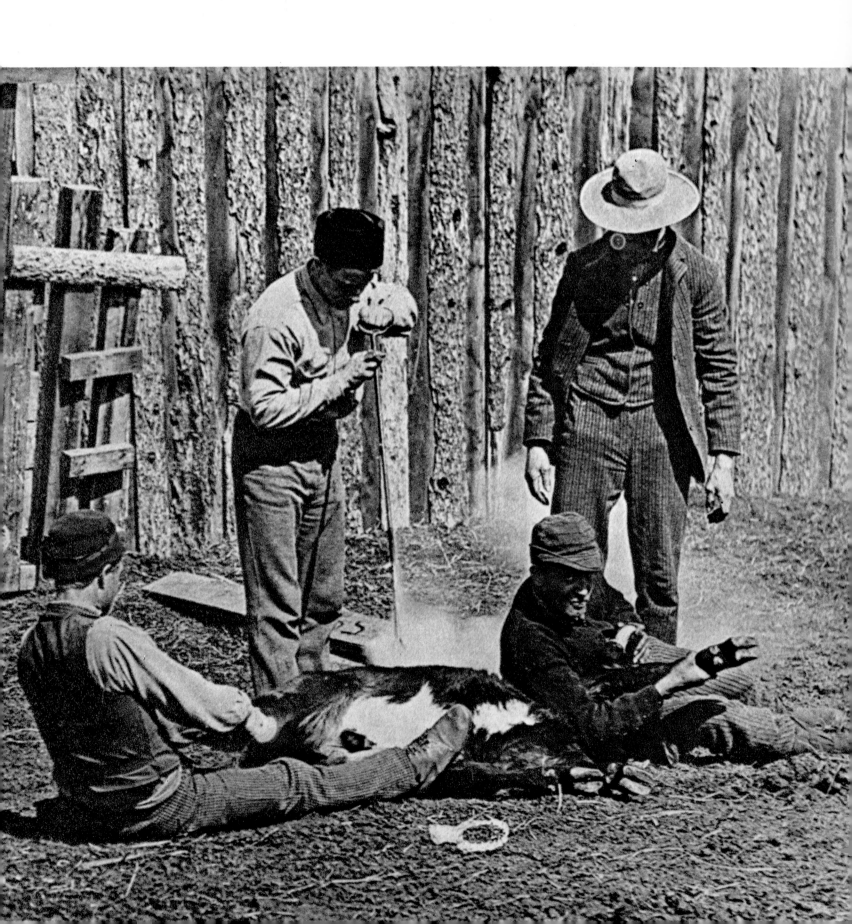

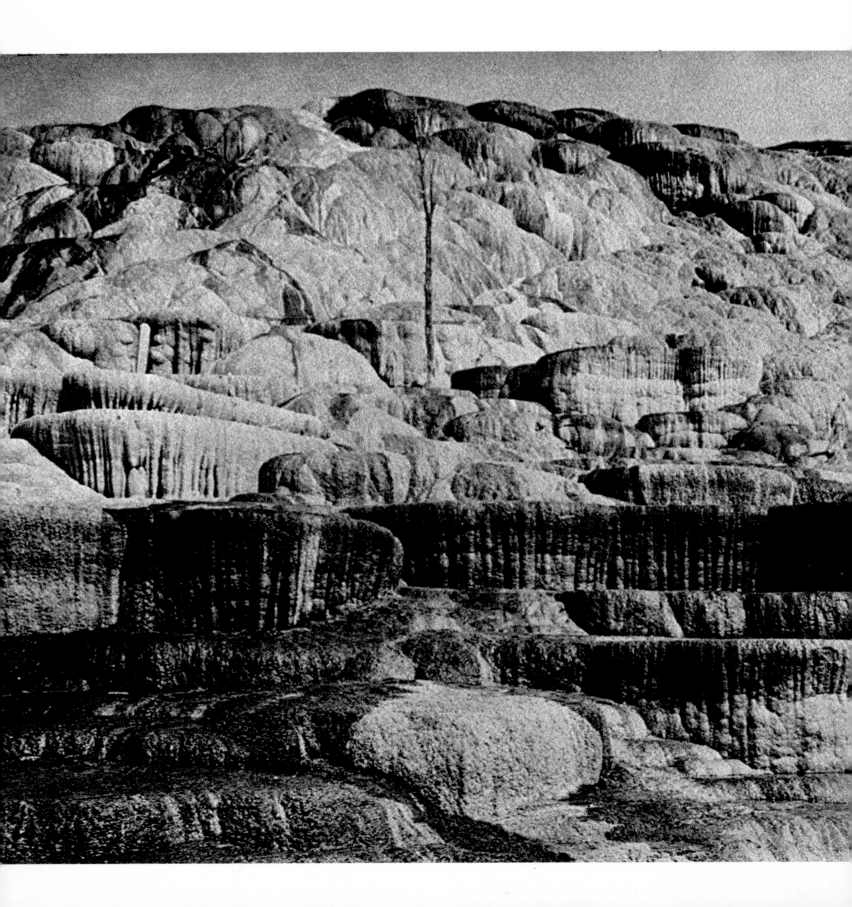

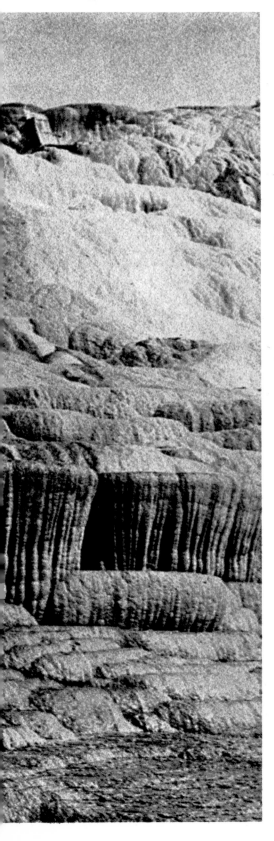

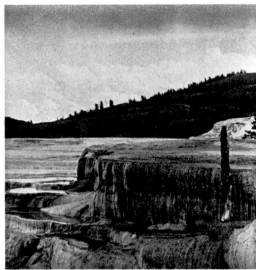

Far left Pulpit Terrace, Mammoth Hot Springs, Yellowstone Park.
Top left Brown Sulphur Springs and Jupiter Terrace.
Bottom left Edge of Great Falls, Yellowstone.

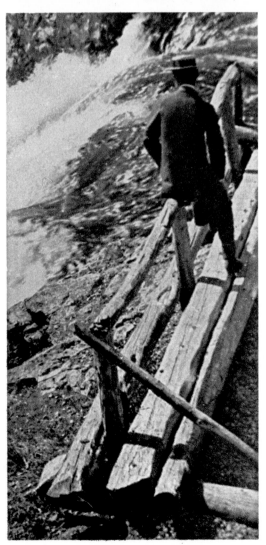

This must have been taken on a dry plate at a very high shutter speed, at least 1/1000th of a second and possibly at 1/2000th, since the spokes of the sulky wheels and the hooves of the trotting horse are both quite sharp. It was probably taken at Pennsylvania University around 1885.

7 Work at Pennsylvania University: Animals and people in action

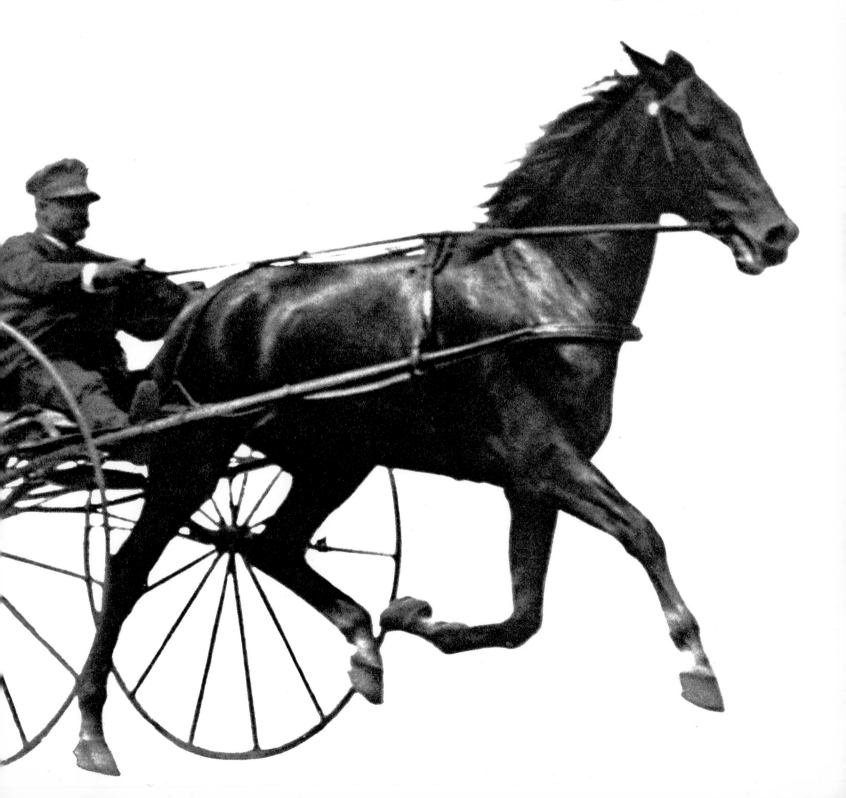

114

Top right The label from one of the
boxes of dry plates that revolution-
ized Muybridge's technique.
Bottom Advertisements for *Animal
Locomotion.*
Far right Plates from *Animal
Locomotion.*

ATTRACTION FOR THE STUDIO
OR RECEPTION ROOM.

$1.00 for a Lasting Attraction.

Almost every one in the United States has heard of the
investigations of Mr. MUYBRIDGE upon the

ATTITUDES OF ANIMALS IN MOTION,

but comparatively few have had an opportunity of seeing the
wonderful results of his labors. Mr. MUYBRIDGE has
recently returned from Europe, where he lectured upon and
exhibited his Photographs in England before

The Royal Academy of Arts,
The Royal Institution,
The Government Schools of Art and Science,
Eton College,

And many other Scientific, Artistic, Literary, Social and Fashionable Institutions

For the purpose of enabling every one to participate in these marvelous
revelations of the camera, Mr. MUYBRIDGE has reproduced, by photo-
lithography, a series of 12 subjects, illustrating the action of the Horse
during a walk, an amble, a slow trot, a fast trot, a rack or pace, a canter, a
run, and a leap over a hurdle; a Hound running, an Ox trotting, a Deer
bounding, and a Bull running, comprising in all 150 figures.
The 12 sets, as explained by the circular accompanying them, are
arranged to show the continuous movement of the subject with life-like
accuracy. The illusion is perfect, and there is the exact appearance of
various motions, such as running, trotting, leaping hurdles, etc.

Price, $1.00 per Set.
SENT FREE BY MAIL.

SCOVILL M'F'G CO., Trade Agents.

HEINRICH'S CELEBRATED GELATINE
FOR DRY PLATES.
TRY IT. Price, $1.38 per pound.

LONDON, 15 Piccadilly, *October, 1898*
EADWEARD MUYBRIDGE'S
Great Work on
ANIMAL LOCOMOTION

THE results of the investigation executed for the University of Pennsylvania are
Seven Hundred and Eighty-one Sheets of Illustrations
containing more than 20,000 figures of men, women, and children, animals and birds,
actively engaged in walking, galloping, flying, working, jumping, fighting, dancing,
playing at base-ball, cricket, and other athletic games, or other actions incidental to
every-day life, which illustrate motion or the play of muscles.

These sheets of illustrations are conventionally called "plates," which have been
printed from **copper plates**, prepared by the "**photogravure**" process.
Each Plate is Complete in itself without reference to any other Plate
and illustrates the successive phases of a single action, photographed with automatic
electro-photographic apparatus at regulated and accurately recorded intervals of time,
consecutively from one point of view; or, *consecutively AND synchronously* from *two*,
or from *three* points of view.

A series of twelve consecutive exposures, from each of the three points of view,
are represented by an outline tracing on a small scale of plate 579, a complete
stride of a horse walking; the intervals of exposures are recorded as being one
hundred and twenty-six one-thousandths of a second.

Only thirty-five large Libraries and Art or Science Institutions in America and
in Europe have subscribed for, and have now in their possession, a complete series
of the 781 Plates, the subscription price for which was
One Hundred and Ten Guineas
in Great Britain for the complete series, bound in eleven volumes, full American-
Russia leather, each plate *mounted on a linen guard*
Philadelphia, University of Pennsylvania, 1872-93

*This grand Monumental Work, of which only thirty-seven perfect
copies were produced, is entirely out of print; the Artist has no
copy left*

I now offer a perfect copy, 11 vols. folio, strongly bound in russia, for
£105.
*Will you secure it? A prompt answer will oblige, as this unique work
is sure to rise in commercial value*

BERNARD QUARITCH

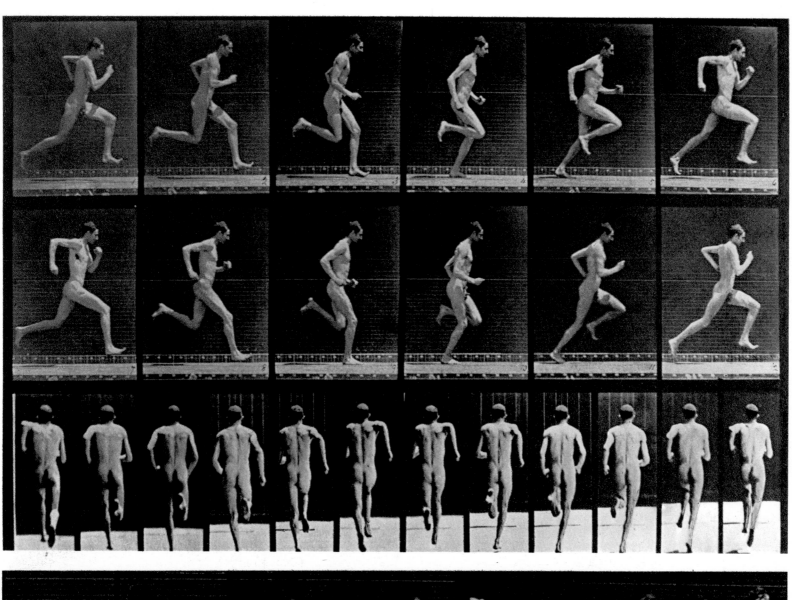

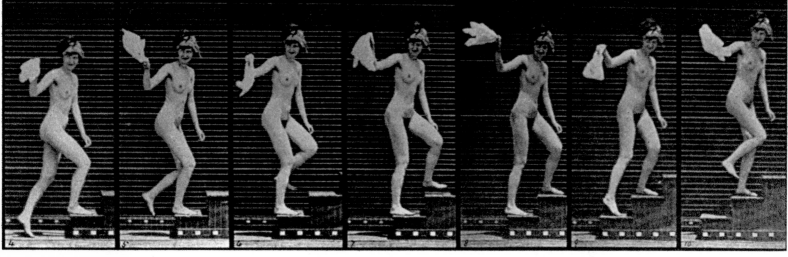

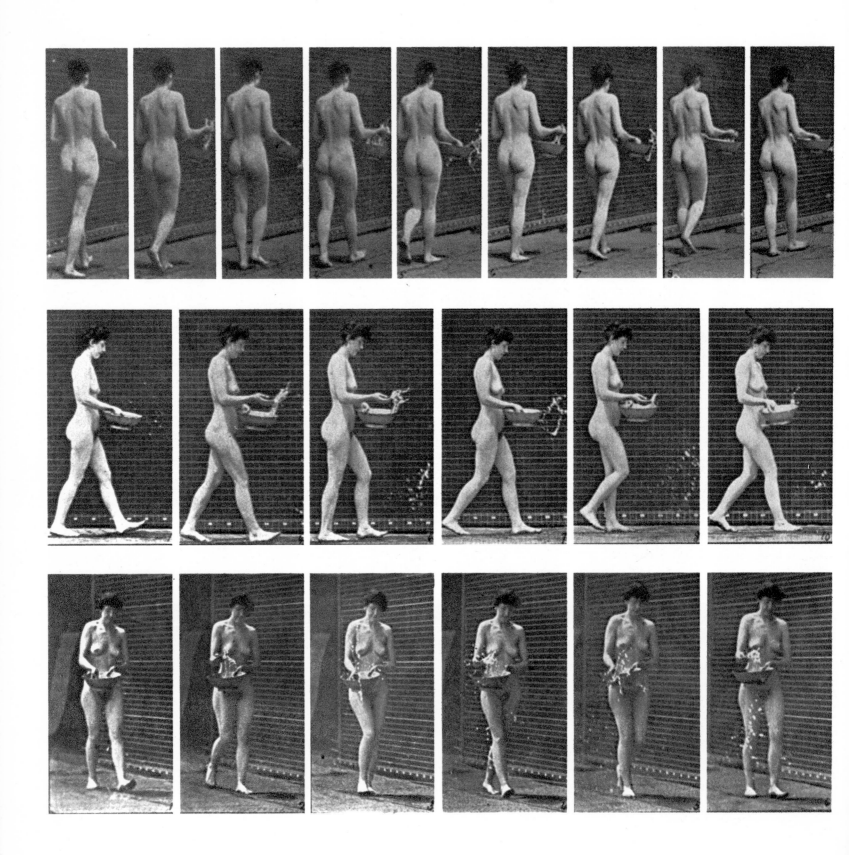

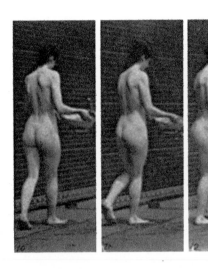

These photographs were taken
from three different angles with
Muybridge's Dallmeyer lens cameras.
The exposure was short enough to
'freeze' the drops of water, probably
1/1000th of a second.

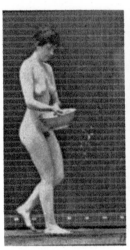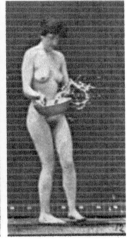

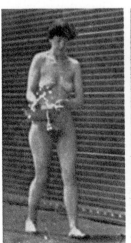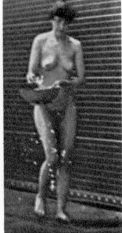

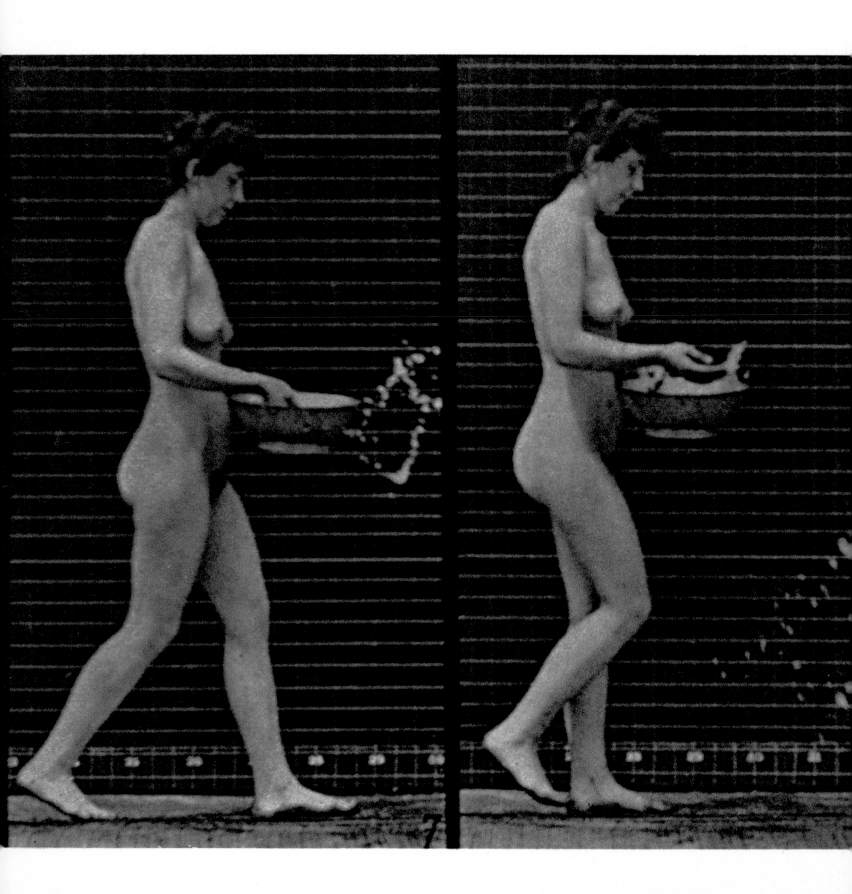

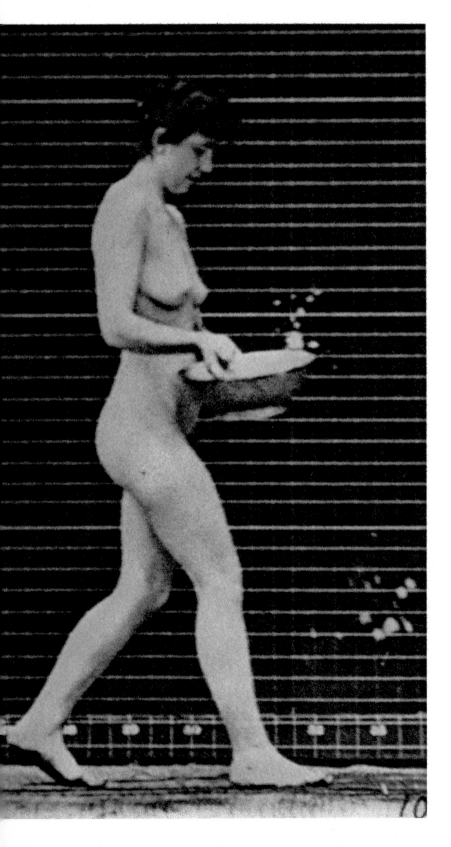

Enlargements from the previous series. By using graph paper ruled in similar squares to the background, an artist could exactly copy the position of the figure at every stage of the movement.
Overleaf Further plates from *Animal Locomotion*.

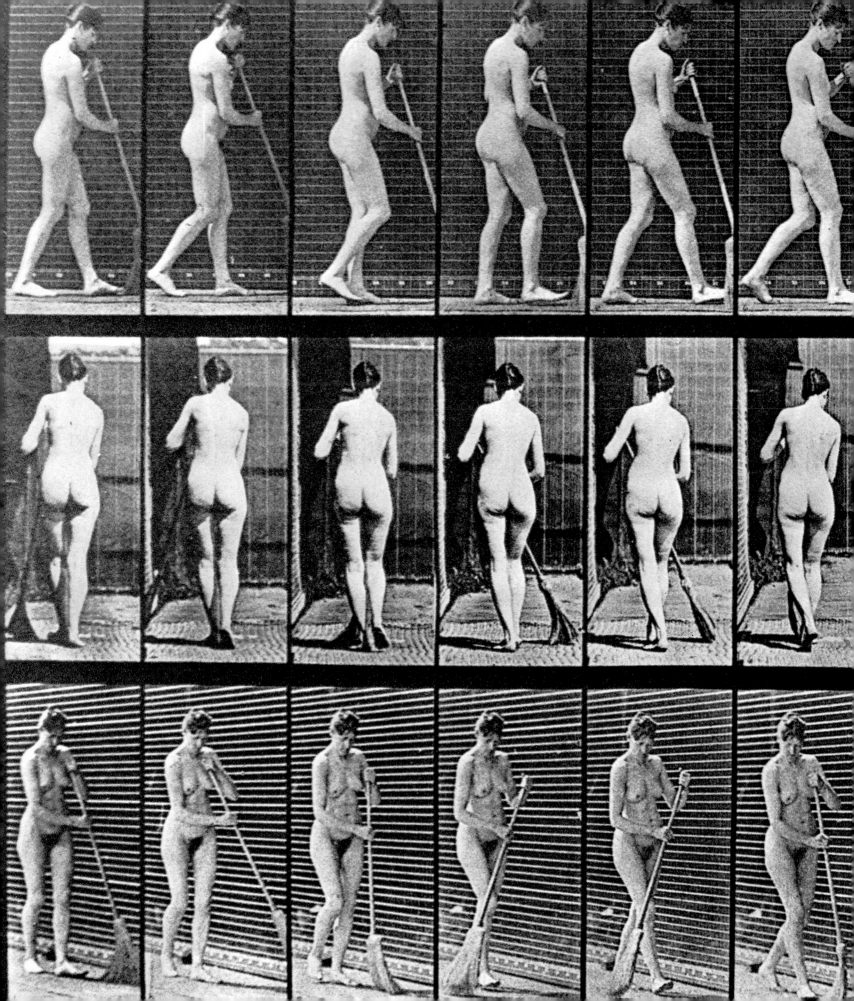

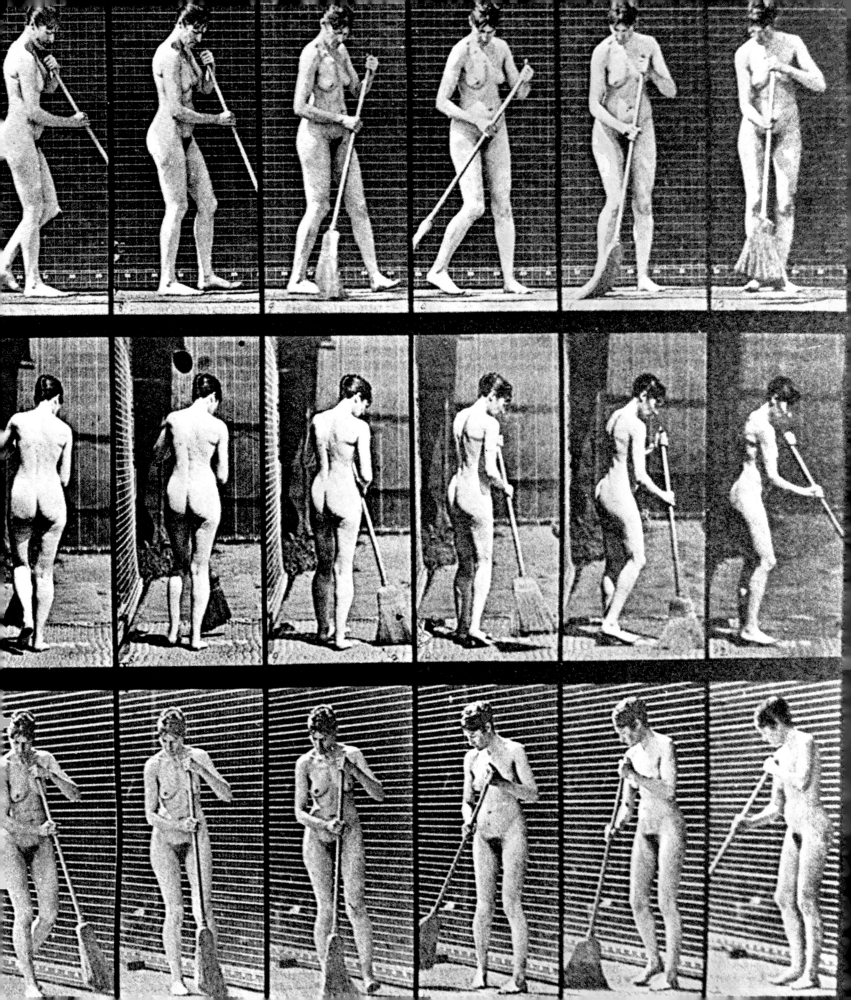

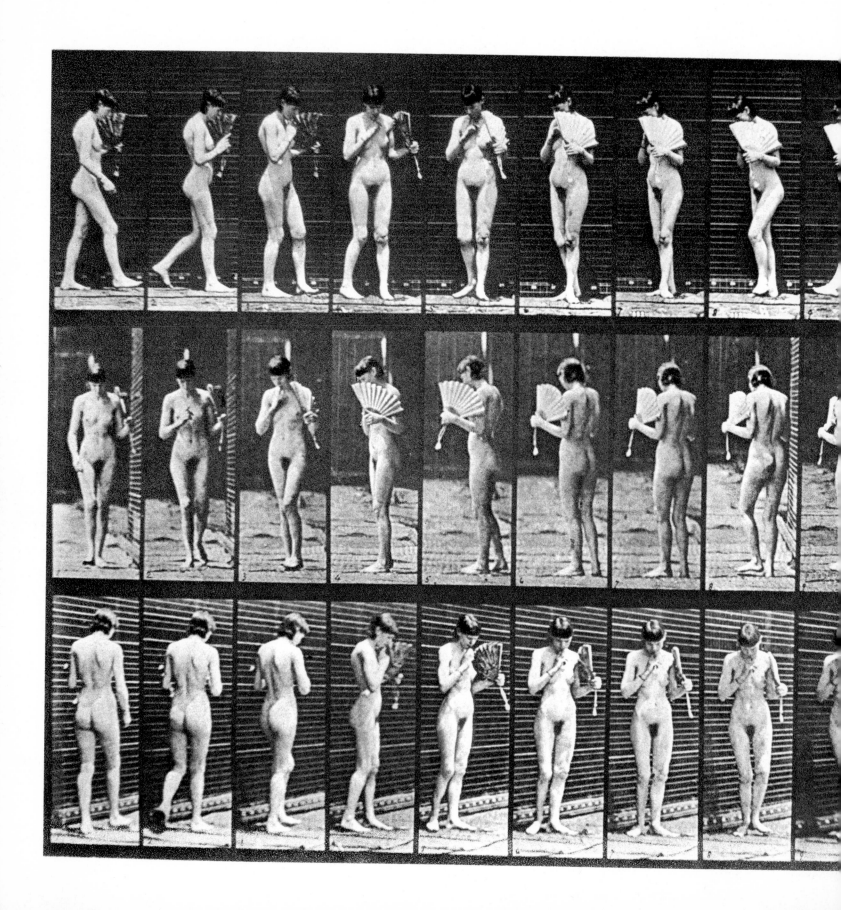

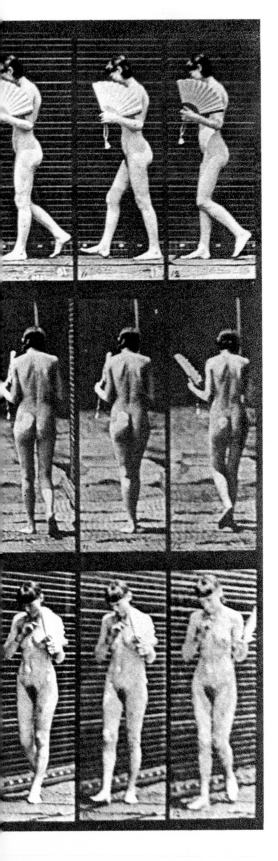

Three matching sets of twelve pictures. It was not always possible to keep exposure and contrast the same for every picture, due to variations in the speed of the shutters and the direction of the light.
Right Clothed model with a fan. From *Animal Locomotion.*
Overleaf Athlete and model: details from *Animal Locomotion.*

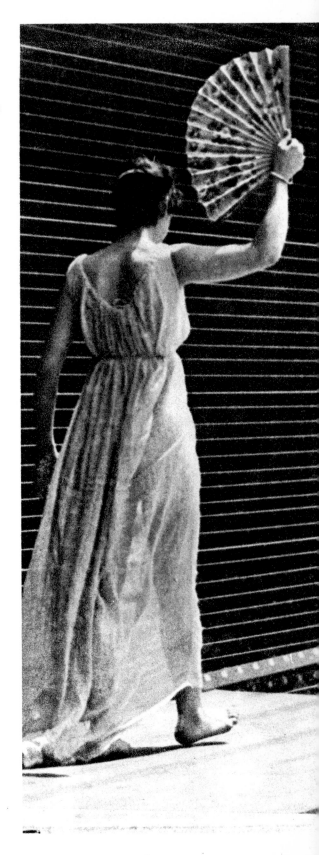

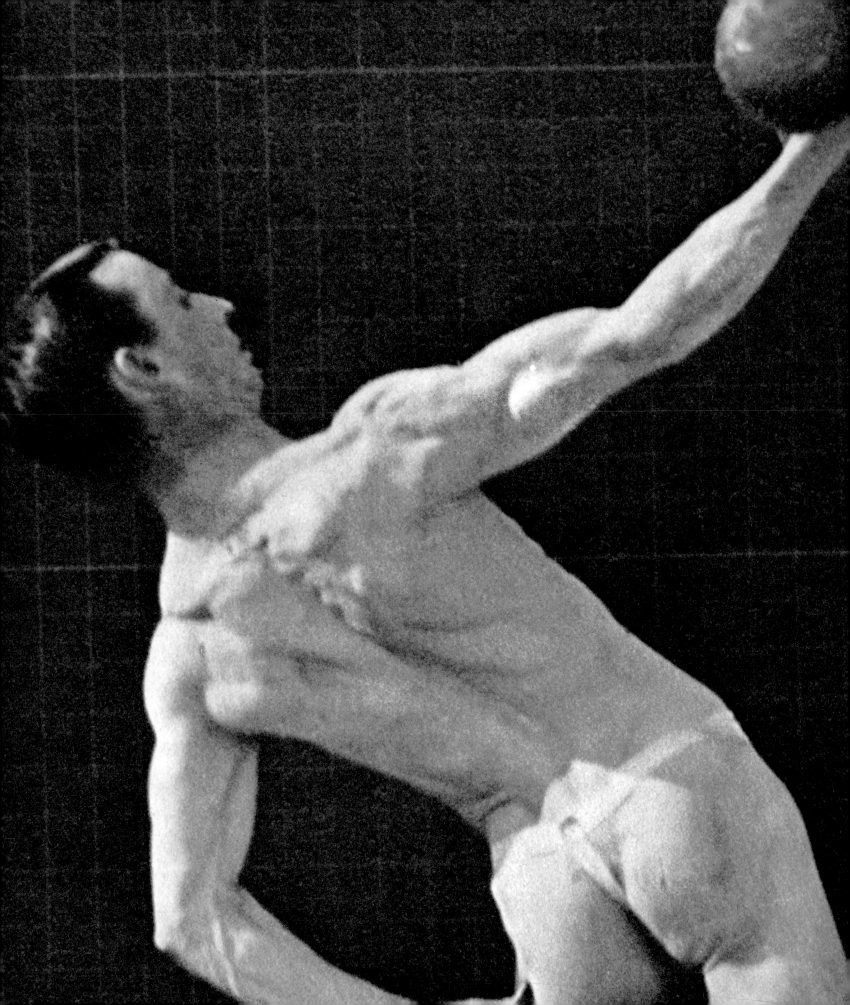

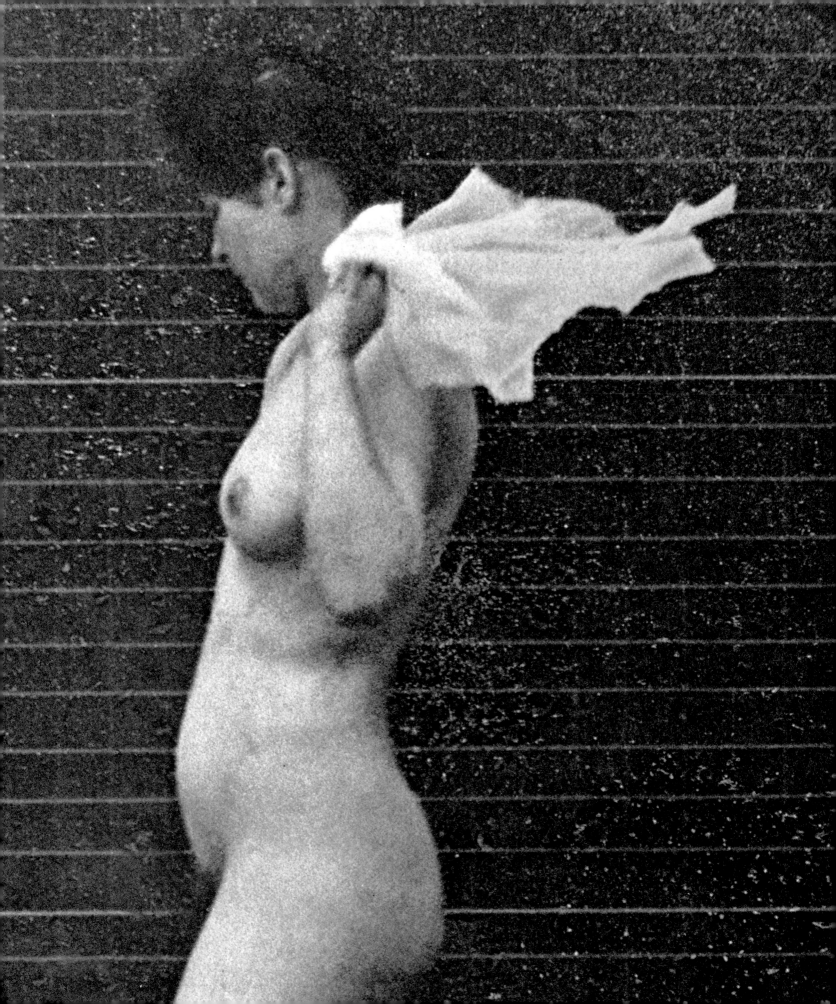

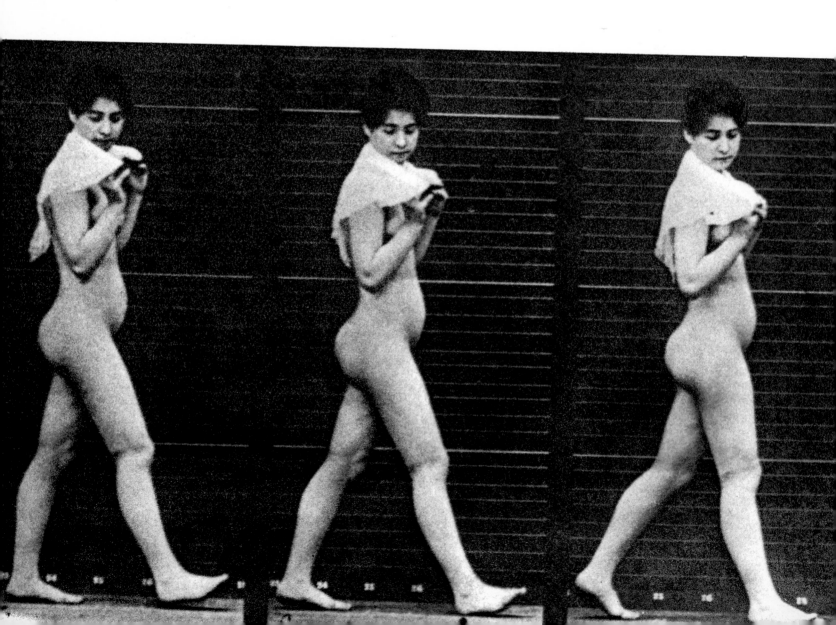

Muybridge used students and graduates of Pennsylvania University for much of his work on animal locomotion, and also a few professional athletes. It is doubtful whether he approached the work quite as seriously as is sometimes supposed.

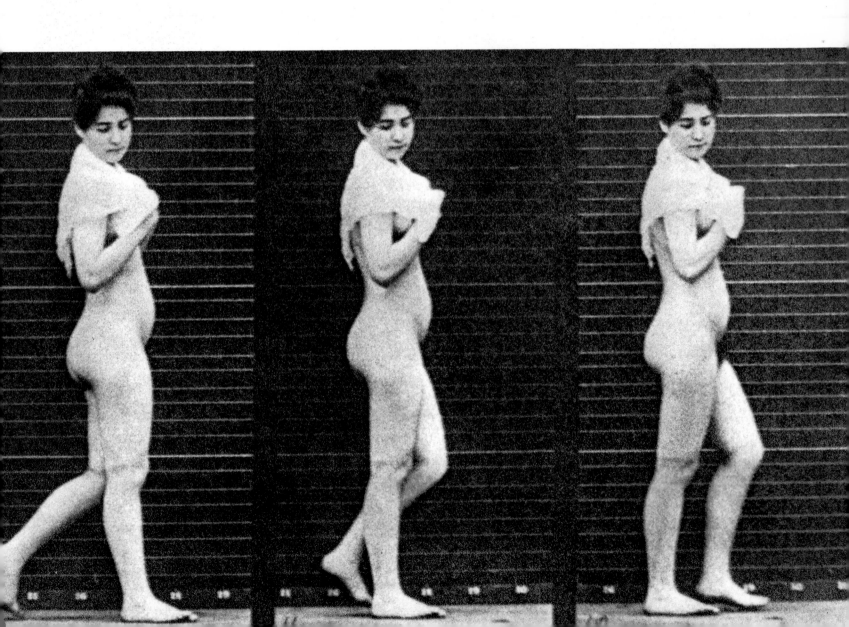

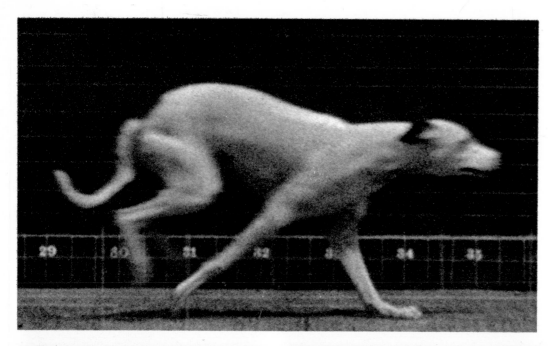
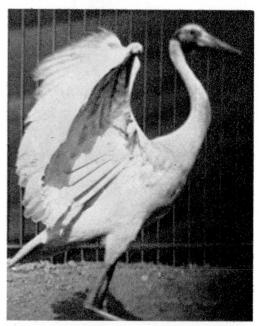
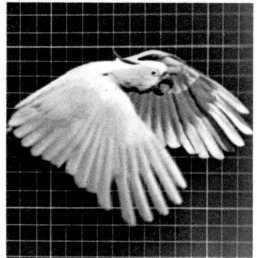
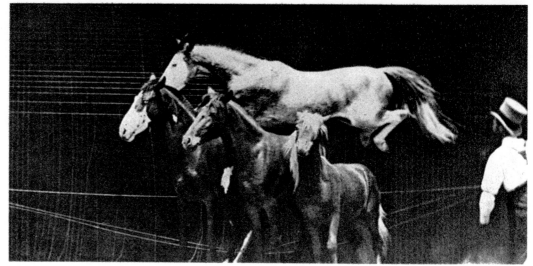

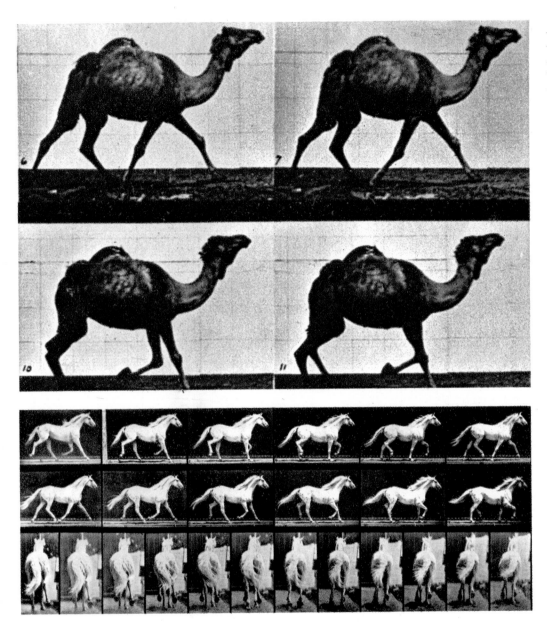

Animals from the Pennsylvania Zoo were put at his disposal, but the leaping horse is obviously part of a circus act.

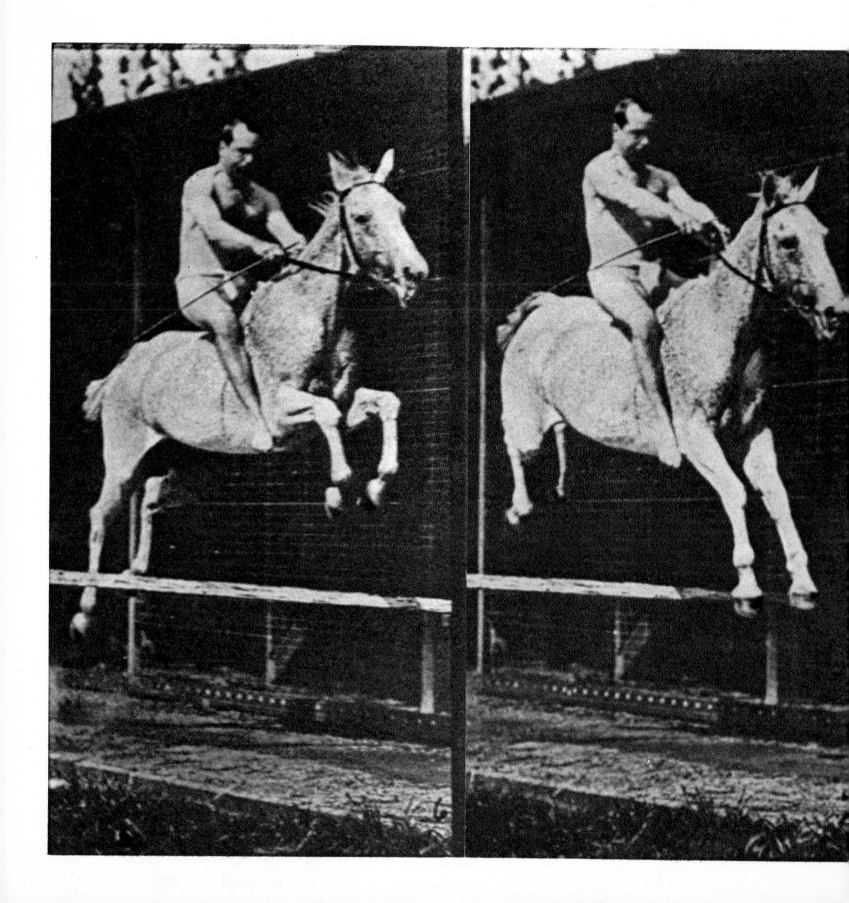

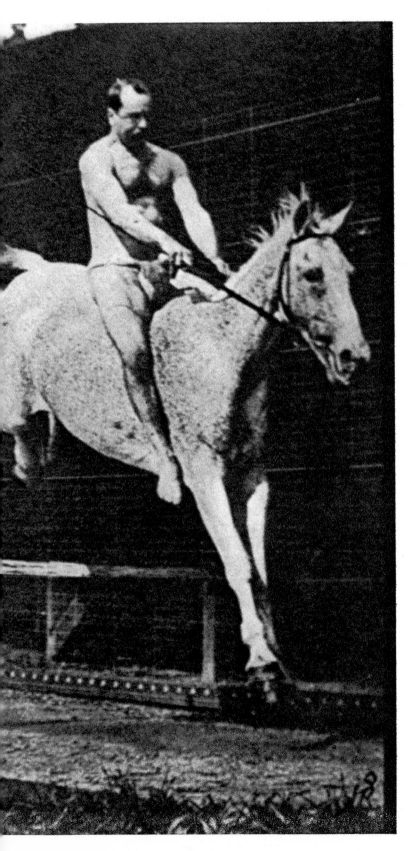

It would be hard to match this sequence of bareback riding with a modern motorized camera.

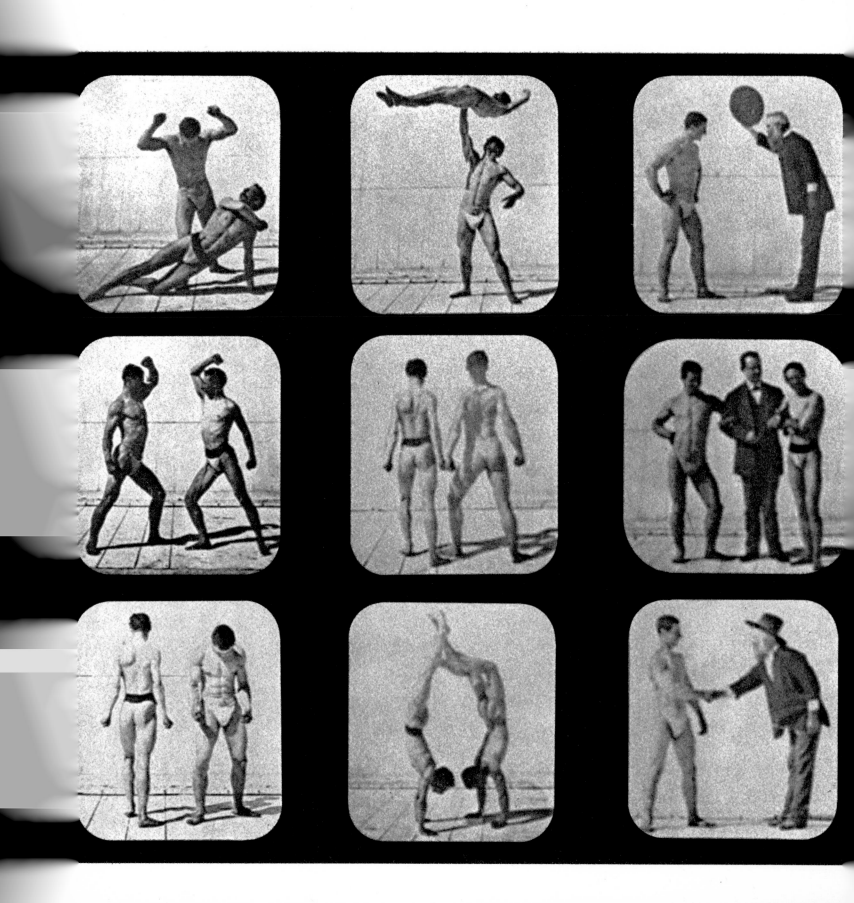

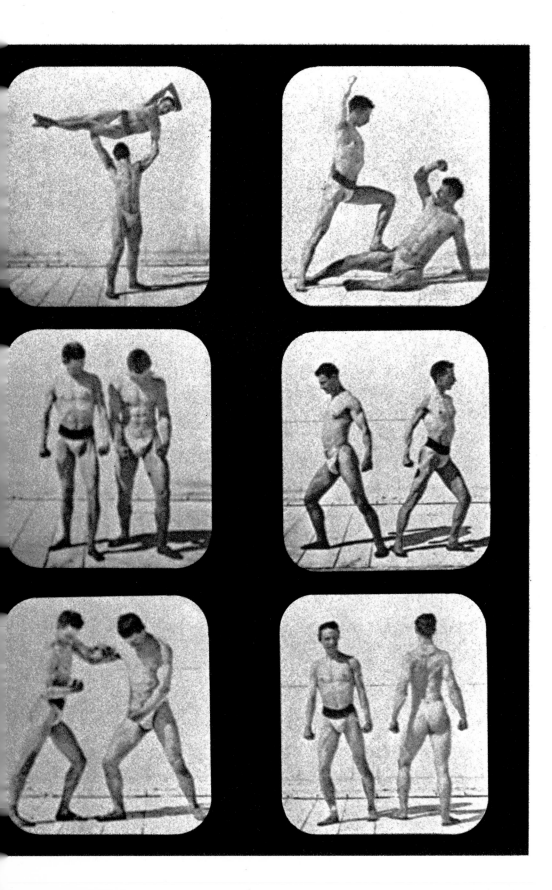

Muybridge is still wearing his black Stetson in this extraordinary series. The man in the centre picture has not been identified.

Superb action pictures of fencing, boxing, running and cricket.

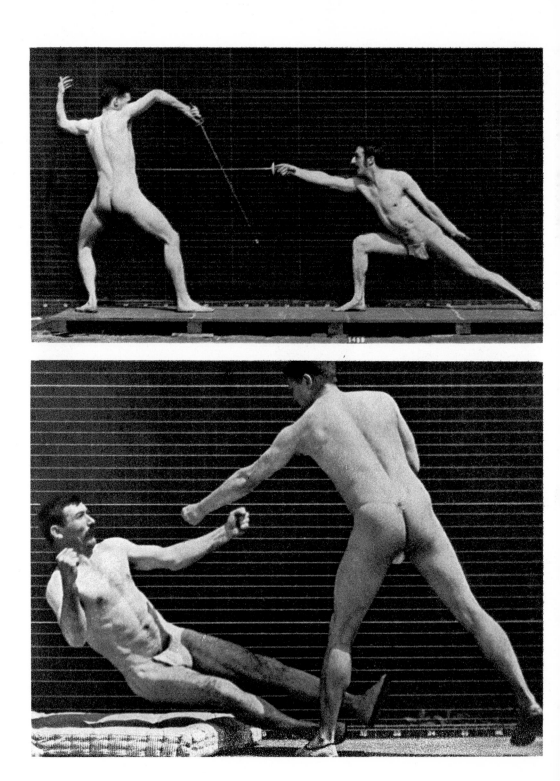

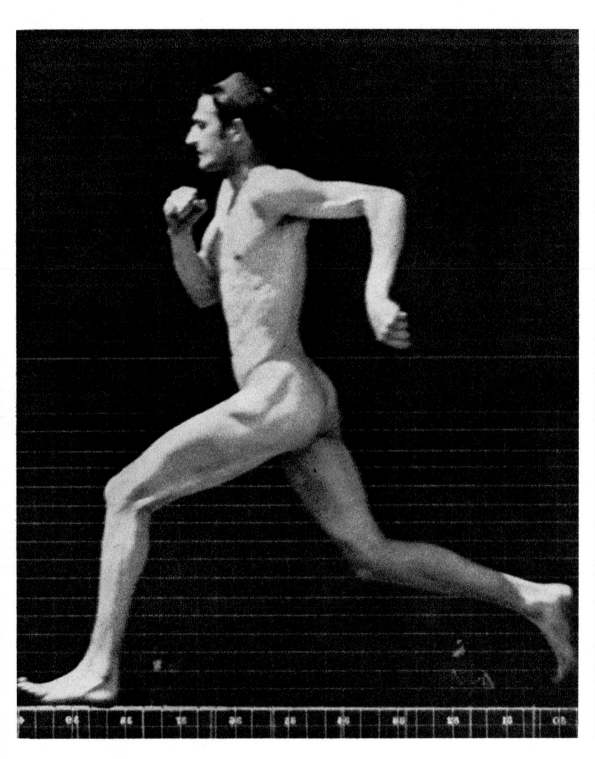

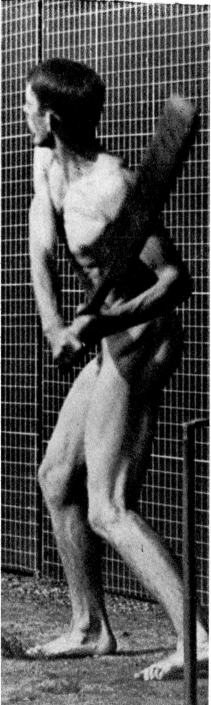

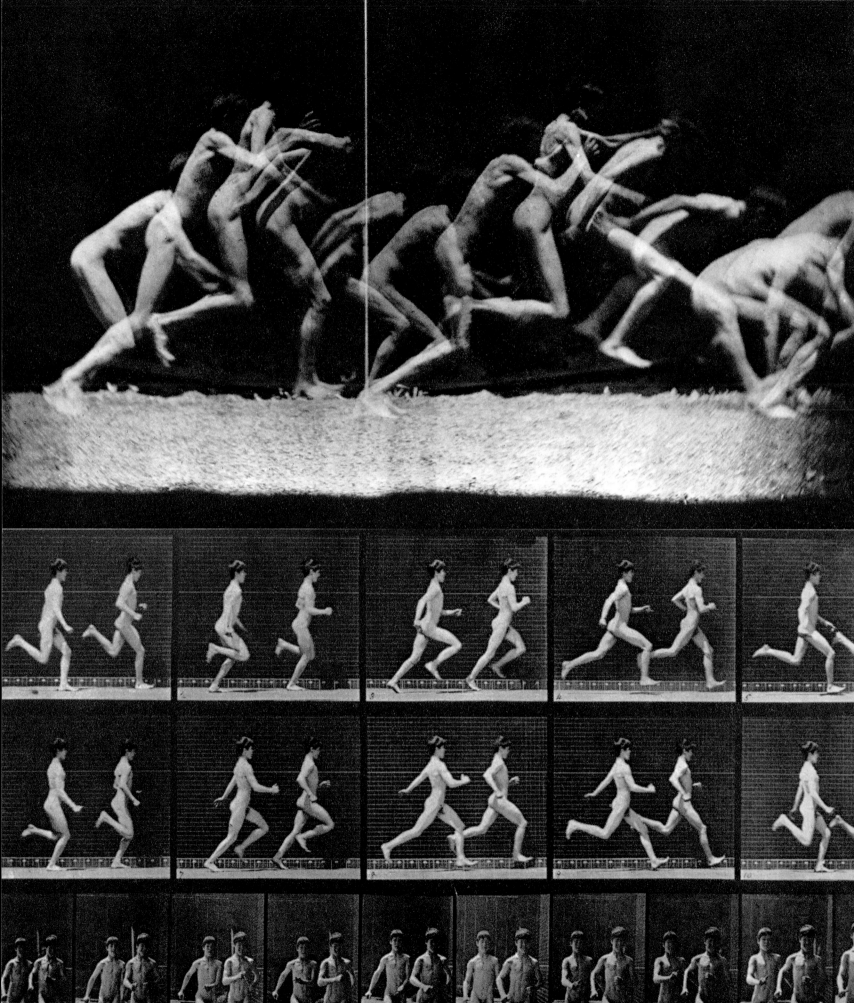

Top left The painter Thomas Eakins
took this multiple image picture of
a boy jumping in 1885. By making
thirteen separate exposures on a
single plate the whole sequence of a
movement could be traced, but the
result did not have as much value
to an artist as those produced by
Muybridge which are shown
underneath. The technique is
commonly used today, with the use
of strobe lighting and a completely
black background.
Below Detail of a photograph on
page 132.

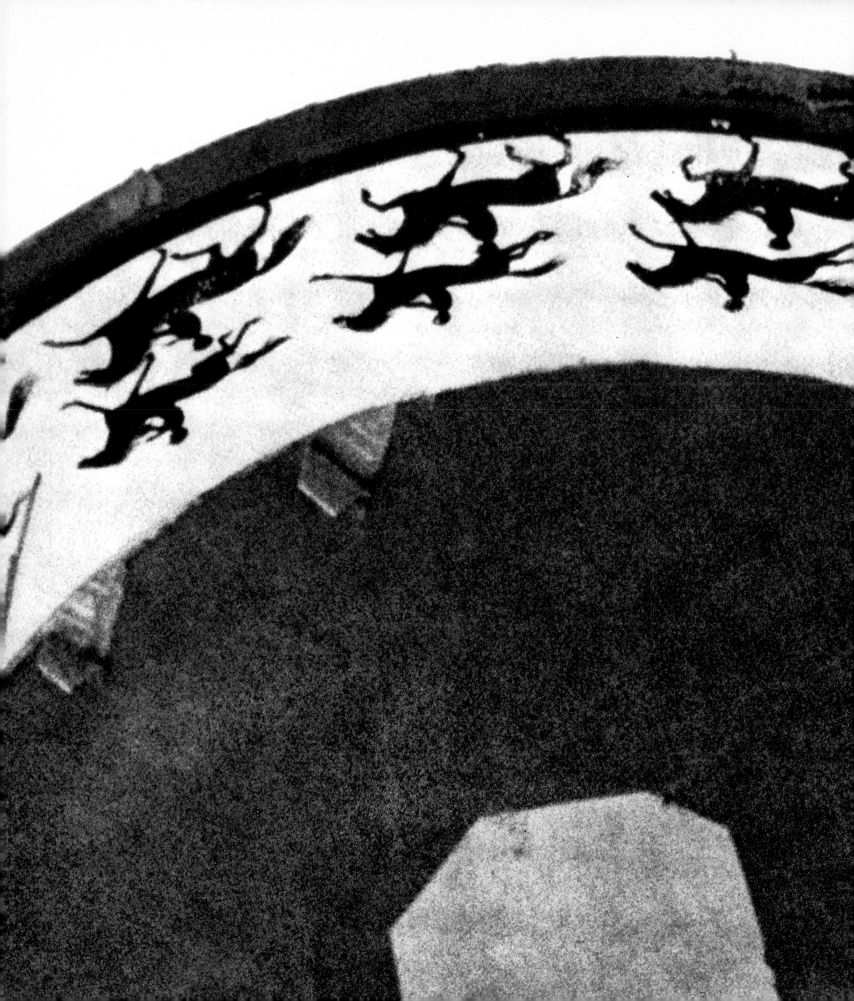

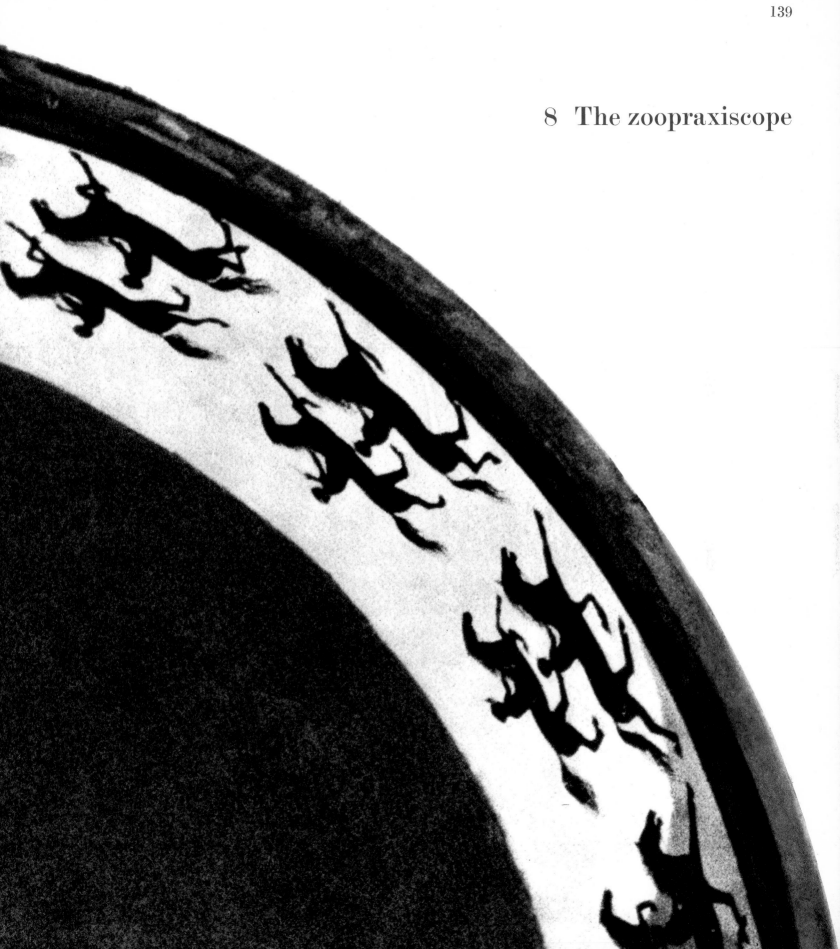

8 The zoopraxiscope

Many of the discs used in the zoopraxiscope were hand-painted by Muybridge, the pictures being based on his photographs. The projector displayed at the Kingston Museum is the original, though the lens has disappeared and been replaced by a contemporary one.

Far right bottom The picture of the jousting knights was copied from a twelfth-century manuscript by Muybridge and the slide was then hand-tinted. It was used in his lectures to show the mistaken idea people had in the past about the movement of a horse.

Far right top *Punch* cartoon caricature of Sir Henry Irving, dated 1882.

Overleaf Detail of the front page of Muybridge's scrap-book.

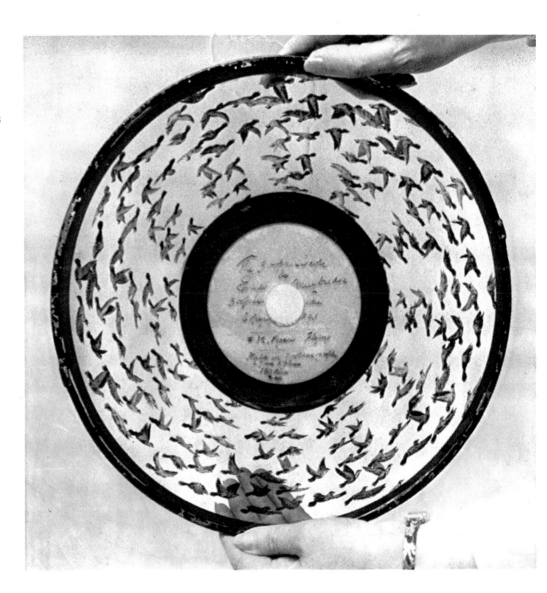

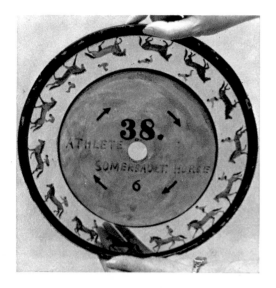

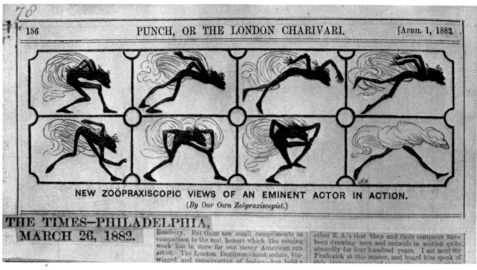

156 PUNCH, OR THE LONDON CHARIVARI. [APRIL 1, 1882.

NEW ZOÖPRAXISCOPIC VIEWS OF AN EMINENT ACTOR IN ACTION.
(By Our Own Zoöpraxiscopist.)

THE TIMES—PHILADELPHIA,
MARCH 26, 1882.

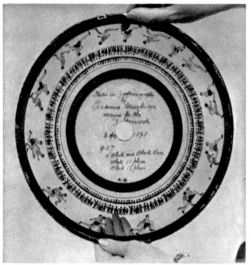

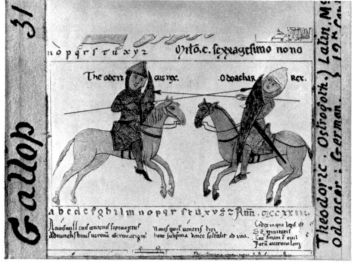

Muybridge of Pal

~~# 7 Montgomery St Jan~~

~~# 9 Broome St New~~

~~2 York St Covent~~

~~# Rue du Chateau d~~
59 Rue de Provence
~~# 9 Strand Londo~~

University of Penn

853 Broadway New Y
The Chestnuts King

alto California

~ancisco (~~More Photographer~~)

~n — Sewin ~~Maub Compy~~

~rden London { British Journal
of Photography

~an Paris — (~~chez Mollini~~)
~aris (chez P. Branden
— (~~American Exchange~~)
~lvania ; Philadelphia
~ (~~Photo-Gravure Compy~~)
— on — Thames England

III Appendices

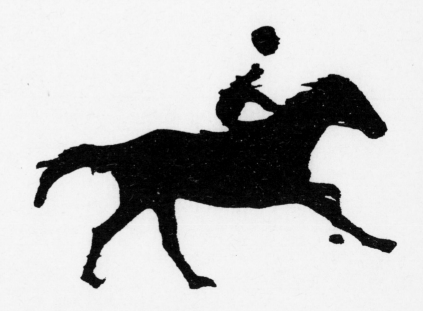

Appendix 1

The Trial of
Eadweard Muybridge

The following extracts from the trial of
Muybridge are taken from issues of the
Sacramento Union which were printed at the
time. This fine newspaper still flourishes
today and my thanks are due to its
editor.

The detailed evidence is given not
because of its sensational or sordid quality
but because no other contemporary
document throws such light on
Muybridge's character and background.

Napa, 4 February 1875
James M. McArthur, sworn. 'Muybridge
gave his name to the Major [Larkyns] and
said "I have brought you a message from
my wife" and instantly fired. When
Muybridge followed him into the house the
witness covered him with his pistol and
disarmed him. He then procured a team and
took the defendant to Calistoga to the
officers. There was but one shot fired.

On the way down the defendant
conversed on the subject of his intentions in
going up. He said he went there to kill
Major Larkyns. He said also he had
arranged all his business in the fear that he
might be killed or lynched. He expected to
find the Major amongst his friends and
determined to shoot him and take the
consequences before he left the house.
Muybridge said he came in the night
because he did not design to give Larkyns a
chance to kill him.

The next day at Calistoga the prisoner
told me that he had no regrets for what he
had done.'

Cross examination: 'Muybridge said he
had, at ten o'clock that morning,
intercepted a letter from Larkyns which
showed intimacy between them. He had for
months previously warned the Major not to
speak to her or he would kill him. He
settled his affairs and took the evening boat
for Vallejo. Muybridge begged pardon of the
ladies for causing the excitement. He said
Larkyns had destroyed his happiness and
that men of family would appreciate his
position. He told the witness that his wife

was a divorced woman when he married
her.'

G. F. Wolf. 'On the 17th of October I
drove Muybridge from Calistoga to the
Yellow Jacket mine. On the way up he
asked if there was any danger of robbers and
asked leave to discharge his pistol, which he
did. On arriving at the Mine he asked for
Larkyns, shot him and chased him into the
house.'

After recess, King, on behalf of the
defense, made the opening speech to the
jury, claiming that he could prove that
Larkyns was a man of bad character; that
he pursued the wife of the prisoner and that
he procured rooms on Montgomery Street by
representing himself as a married man, and
induced her to accompany him there, of
which fact he boasted to his friends.

Circumstances having aroused Muy-
bridge's suspicions, he visited the house and
discovered the picture with the name of the
man whom he had forbidden his wife to
speak to. Mrs Smith [the landlady] then
told him all, and from that moment he was
not himself. Strung up to the pitch of
insanity, he made up his mind that he must
slay the destroyer of his happiness – the
man who had debauched his home. The
prisoner went to kill that man. He would
have followed him to the ends of the earth
for that purpose. We claim a verdict both on
the grounds of justifiable homicide and
insanity. We shall prove that years ago the
prisoner was thrown from a stage, receiving
a concussion of the brain which turned his
hair from black to grey in three days and
has never been the same since. We shall
show you the depths of his impassioned love
for his wife; that he was wrapped up in her
and lived only for her. Having shown all
this we shall ask you, as the law does, to
look on his acts with mercy.

Mrs Susan C. Smith. 'Muybridge came to
my door saying "Mrs Smith, I want to see
you about my wife." I declined telling him.
He said "I consider you a bad woman."
(he thought it was only a flirtation). I
replied "I am not a bad woman."

His wife came to me at half-past two in

the morning with Larkyns and wanted me to go down with her to the corner of Howard and Third Streets, as she wanted me as a nurse. Mrs Muybridge engaged me. When the doctor came, Larkyns came also and bent over her when she was in bed and in the agonies of child-birth. He was there more than two hours at a time, Muybridge being absent.

When I told Muybridge he cried like a child, saying "Can it be possible that that man was frequently in my bedroom alone!" and in great agony of mind wandered about. Seeing a picture of the baby he took it up and on the back was written "Harry" in his wife's handwriting; he seemed crazy.

He then asked me "Whose baby is that – mine or Larkyns?" "I do not know", I replied.

I was asked to take care of the baby by Mrs Muybridge while she and Larkyns travelled together with Wilson's Circus. I declined. Larkyns called one afternoon between two and four, when they entered a room and were together. I was called in and there lay Mrs Muybridge, her bosom bare, and Larkyns with his hand on her shoulder. I asked Larkyns who the baby was like. He replied "You ought to know; we remember the 13th of July, don't we, and have something to show for it", looking at the baby with a smile.

Muybridge forced me to tell him all, and this was what I told him. What led to the conversation was that I had sued Muybridge for $100 for services rendered as a nurse and had won the suit, but he declined paying me until I told him all about Mrs M.

I refused to give him letters in my possession which he demanded but he said he would fetch his attorney and I did so then. On reading a few lines he fell to the floor crying "Oh God! Oh God! Is it possible?" '

Miss Louisa Smith. 'I know both the defendant and Major Larkyns intimately; I work for Muybridge at Rulofson's Gallery. He was always kind to his wife and always gave her all the money she wanted. He is easily excited and very nervous at times.'

Rulofson himself was then called and asked if he had ever seen any evidence of eccentricity. 'Severe! He would take a dislike to someone in his establishment but be satisfied with an explanation. Soon he would refer to them as though they had never been mentioned before. Bargains made one day would be misunderstood and misstated the next. This occurred from thirty to forty times within the last two years – he is a very pleasant man to do business with, except on such occasions.

He was engaged mainly in photographing scenery in different parts of the country. He generally spurned money and would never make a view for money if he did not see beauty in it, but would drop his tools and pack up at once. Judge Crocker owed him a large sum of money – about $700 – and because he heard that the Judge questioned it somewhat he immediately made out a receipted bill for the whole amount. Instances of this kind were numerous.

About half-past two on October 17th I met him at the elevator. He was very white and pale and I placed my hand upon him and said "What is the matter, my boy?" I was really afraid that the quivering of his whole frame was developing into insanity, and afraid he might do some rash act. I asked him again what was the matter. Large drops of sweat oozed from his colourless face, but he couldn't tell me. He begged me that when I came to settle up his business I would give everything that belonged to him to his wife, "as I have something to do". Supposing him to be about to commit suicide I said to him "I took you to be a man, not a coward!" He answered "No! Not that, upon my honour."

Presently I succeeded in drawing a few words out of him and he showed me some letters. Some I recognised as being from Larkyns, whom he said had dishonoured him. He gave me the letters, making me swear to destroy everything that reflected on his wife's good name. I tried to calm him and also to detain him until the boat had gone, as he had said that Larkyns was at Calistoga. But I found it impossible and

at five minutes to four he started off abruptly.

I have known Muybridge to sit up all night reading, generally some classical work. He has been eccentric for the last two years.'

Mr Gray. 'I have resided in San Francisco for the last twenty years, and have known Muybridge intimately for that period. I remember his going to Europe in 1859; he was absent between six and eight years. He was much more irritable after his return, much more careless in his dress and was not such a good businessman. Though he was not grey when he went away, he was very grey on his return. He has not been the same man in any respect since.'

Silas Seleck, photographer. 'I have known Muybridge for twenty-six or twenty-seven years. I knew him in New York City and met him in California in the autumn of 1855. We were intimate until his departure for Europe in 1860 – I think he returned here in 1867. From 1852 to 1867 Muybridge was a genial, pleasant and quick business-man; after his return from Europe he was very eccentric, and so unlike his way before going. The change in his appearance was such that I could scarcely recognise him after his return.

I have seen him almost daily for the last six months – his ways and expression of face were odd, especially at times. One evidence of his singularity was that he took the letter "g" out of his name and substituted a "b". He brought some $4,000 worth of goods back from Europe and though he sold some to other people he wouldn't sell me any. Instead he told me to take anything I wanted as if it were my own. He always was exceedingly generous . . .'

Napa, 5 February
Nearly everyone in Napa is very much interested in the result of the present trial, and there seems to be a general impression that Muybridge will be acquitted. He has the sympathy of the people generally; that

perhaps may be interpreted as a good indication of the result of the trial. Muybridge is in moderately good spirits and last night I spent an hour with him.

It was very amusing to listen to his experiences in jail. For instance, a Chinaman was brought in and one of the 'hardened' began to abuse him. 'Stop that' said Muybridge, 'none of that here. I will not allow it, sir. No man of any country whose misfortunes bring him here shall be abused in my presence.' 'How are you going to prevent it?' was Hardened's reply. 'I will take you by the neck, sir, and throw you into your cell and keep you there the moment you attempt to insult anyone, sir.' This ended the controversy.

At another time an old prison-bird who had seen the inside of most of the prisons of the State began to use coarse and profane language. Muybridge immediately asked him what he meant by using such profane language in his presence, or in that of the other prisoners, saying that he ought to be ashamed of himself. The prison-bird wanted to know 'what right he had to talk to him'. 'The right that every man has when he feels disgusted, as I do, with such uncalled for profanity, and if you don't stop it, I will make you.' This had the desired effect. Muybridge feels a little proud of his influence in such a place and says they one and all treat him with marked respect. He also speaks very warmly of the officers of the prison and of their uniform kindness and indulgence to him.

The trial was resumed at 9.30 a.m.

Muybridge. 'I am the defendant in this case. I left this State by the Southern stage route in 1860. I recollect taking supper at a wayside cabin, but remember nothing that transpired after that for nine days, when I found myself at Fort Smith, 150 miles from the cabin. I saw a man sitting on my bed, but he was to my vision two – everything was double. I had no taste, no smell and was very deaf. There was a scab upon my head and I was troubled with a bad headache.

I recognised the man sitting on the bed as one of my fellow-passengers and he told me that after leaving the cabin the wild horses ran away with the stage, just as we had reached the "cross-timbers" of Texas, and that the stage had struck a stump and upset. Two persons were killed and the others badly injured.

I was detained there for about three weeks under medical treatment; then I went to New York and placed myself under the medical skill of, I believe, a Dr Parker. I could not stay in New York on account of the noise and was sent to the sea-coast, but could not endure the house. I then went into the country and began to improve; after about six weeks in New York I felt well enough to take a voyage across the Atlantic. In London I placed myself under the medical care of Sir William Gull and was forbidden the use of meat, spirits and coffee for over a year. I was in perfect health before the accident and had never been sick in my life.'

After a recess some minor evidence was heard and then Rulofson was recalled. 'I saw Muybridge the second or third day after the homicide and had an interview with him. He fell upon my neck and wept bitterly, saying he was very sorry. Immediately after he straightened up saying "I am cool" and denying being excited. He was always very calm and his excitement was unlike anything I had ever seen before. These paroxysms were only when his wife or his honour were named.'

Dr Shurtleff, Superintendent of Stockton Insane Asylum, was then asked if in his opinion Muybridge was of unsound mind when he shot Larkyn. He gave a lengthy reply, couched in the psychiatric jargon of the day, which when summarised said 'No'.

After a recess the Judge summed up, saying the attempts to show insanity were puerile and ending by saying 'You stick to the law, gentlemen. A jury must decide upon the law and upon the evidence, even if it makes their hearts bleed to do so. If you decide that this man is not guilty, you add another to the catalogue of those who have defied the law.' The court then adjourned.

The *Sacramento Union* published the following two letters which had been mentioned in the case.

The first was from Larkyn to Mrs Smith.

Calistoga

Dear Mrs Smith,

You will be surprised to hear from me so soon after I left the city, but I have been so uneasy and worried about that poor girl that I cannot rest, and it is a relief to write and talk about her. I think you have a sufficiently friendly feeling towards me to grant me a favour. Rest assured I will find means to do you a good turn before long. I want you and your girls to be perfectly frank, open and honest with me. If you hear anything of that little lady, no matter what, tell me right out. She may return to the city and beg you not to let me know; but do not, pray do not, listen to her. Do not be afraid that I will get angry with her. I will never say a harsh word to her, and even if things turn out as badly as possible, and I find she has been deceiving me all along, I can only be grieved and sorry, but can never be angry with her. I ascertained today that all the minstrels will return from Portland on the next steamer, which will arrive on Tuesday. I cannot and will not believe anything as bad as that rumour, but I almost believe she will come back, or she would have sent for her clothes. I have written to the morning and evening papers in Portland today and advertised in the 'personals' so –

'Flora and Georgie; if you have a heart you will write to H. Have you forgotten that April night when we were both so pale?'

She will understand this. I have also put a personal in the Chronicle. Mrs Smith, I assure you I am sick with anxiety and doubt, the whole thing is incomprehensible and I am so helpless. I fear my business will not let me go to Portland and I see no other way of hearing of her. If an angel had

150

come and told me she was false to me I would not have believed it. I cannot attend to my work, or sleep, I cannot help thinking of that speech of hers to you the day before she left, when she begged you not to think ill of her, whatever you might hear. It almost looks as though she had settled some plan in her head that she knew you would disapprove of. And yet, Mrs Smith, after all that has come and gone, could she be so utterly untrue to me – so horribly false? It seems impossible, and yet I rack my brain to try to find some excuse, and cannot do it. If she had nothing to conceal, why does she not write? If I go to Portland I must give up my situation; but I think I shall go unless we hear. I shall be in the city about Thursday next. Tell the girls to look out for the next steamer and see if Flo is coming down. Mrs Smith, again I beg you to be open and candid and conceal nothing from me. With many thanks for all the kindnesses you have shown Flo, yours truly,

Harry Larkyns

The second was from Mrs Muybridge.

The Dalles (Oregon)
Dear Sarah,

Yours of the 3rd has just come to hand. I had begun to think you had all forgotten me. I received such a letter from H.L., saying that he heard that I had not gone any further than Portland. I was so provoked that I wrote him a letter and sent it to the Geysers, and which, if he receives it, will not make him very happy. He ought to know me better than to accuse me of such a thing, but I may forgive him. Don't forget to tell him, if he wrote to me at Portland, to send and get the letter, as it might be advertised and sent for by someone else.

She or anyone else may talk about Harry all they please. I am not ashamed to say I love him better than anyone else upon this earth and no one can change my mind, unless with his own lips he tells me that he does not care for me any more.

I don't want Harry to come up here,

much as I would like to see him, for this is a small place and people cannot hold their tongues.

Mrs Muybridge
Destroy my letters after reading them, for you might loose one, and it might get picked up. Flo

The court reassembled at 6.45 p.m. and the final argument for the defense began. It lasted for two hours and the style can only be described as nineteenth-century theatrical. Larkyn had staked his life against a moment of sensual gratification. Muybridge loved his wife with all the love of a strong, self-constrained man. Like a clap of thunder from a clear sky came the revelation that his whole life was blasted. He learned that she had been false to him in every way – false even to the extent of palming off upon him as his own the child of her libertine seducer.

The ending was, however, prophetic. 'I cannot ask you to send this man back to his happy home. The destroyer has been there and has written all over it, from foundation-stone to roof-tree, the words "Desolation! Desolation!". His wife's name has been smirched, his child bastardized, and his earthly happiness so utterly destroyed that no hope exists of its reconstruction. But let him go forth again amongst the wild and grand beauties of nature in the pursuit of his loved profession, where he may perhaps pick up again a few of the broken threads of his life and attain such comparative peace as may be attained by one so cruelly stricken through the very excess of his love.'

The Court shook with applause and the judge had one man arrested.

The District Attorney then made the closing speech for the Prosecution. In brief, he stated that Muybridge was not insane and had not sufficient justification. He attacked Mrs Smith as a go-between and a traitor. He asked for no compromise verdict. If the prisoner was not guilty of deliberate murder, then let him go free.

The jury retired for twelve hours and

gave the verdict 'Not Guilty'.

'At the sound of the last momentous words a convulsive gasp escaped the prisoner's lips, and he sank forward from his chair. His lawyer caught him in his arms and thus prevented his falling to the floor, but his body was limp as a wet cloth. His eyes were glassy, his jaw set and his face livid. He moaned and wept convulsively but uttered no word of pain or rejoicing. He rocked to and fro in his chair. His face was horrifying in its contortions as convulsion followed convulsion. The Judge left the Courtroom, unable to bear the sight and the Clerk hid his face in his handkerchief...'

He recovered after a quarter of an hour and walked into the street. A large crowd had gathered to cheer him and everyone wanted to congratulate him personally. Never before had the town been in such a state of feverish excitement, said the reporter.

It turned out that the jury had dismissed the plea of insanity at once. However, they felt the shooting of Larkyns was justified, since under the same circumstances they would have done the same thing themselves.

The final paragraph in the *Sacramento Union* reads – 'For his wife he uniformly, after his arrest, spoke in pity rather than passion. Since his acquittal he has spoken in the same spirit, saying he would always regard her with compassion for her fallen estate, and that so long as he lives and has a dollar or the means of getting one, she shall not come to want. He will resume his connection with the photographic establishment of Bradley & Rulofson, and as soon as he can make arrangements with the Pacific Mail Company will go upon the professional trip through Mexico and South America, which he had in contemplation when the troubles from which he has just emerged came upon him.'

Appendix 2

Muybridge's Technique

The man who is said to have taught Muybridge photography, Carleton Watkins, used cameras in the rough Yosemite Valley country which took plates 22 × 28 inches and 21 × 16 inches in size. Muybridge probably started on such giant apparatus, but switched to the much smaller size of whole plate (8½ × 6½ inches) for his own early expeditions. Photographers made big negatives because it was the only way in which they could get big prints; though Claudet had printed life-size portraits from 2¼ × 3½-inch negatives in 1862, the time needed for the printing exposure was over an hour. The only way to mass-produce prints for commercial purposes was to contact print them.

Early models of these huge 'field' cameras were made entirely of wood, a smaller box telescoping in and out of a larger one for the purpose of focusing. Heavy and bulky, they were really unsuitable for use away from the studio, but contemporary cameras using bellows were not rigid enough for the very long exposures needed for big plates. By Muybridge's time, however, camera construction had greatly improved and bellows field cameras were in general use, but it is significant that the one he used himself in the Yosemite Valley was, by the standard of the day, a miniature.

The design became finalized around 1870, only minor improvements being made after that date. They were the standard cameras for commercial and technical photography until quite recently and very many are still in use, but as far as I know there is only one man in the world who still seasons his planks of mahogany for many years, cuts out the brass fittings by hand and, without the use of plans or drawings, turns out a precision instrument through sheer craftsmanship. Forty years ago there were dozens of firms doing such work and seventy years ago there were hundreds.

The lenses used by Muybridge for his landscapes would have been two or three element 'achromatics' which, by combining Crown glass with Flint glass could be made to give sharp results provided the aperture was sufficiently small. In the United States such lenses were being made by Harrison & Co., but the ones made by Dallmeyer, Ross and Grubb in England and by Voigtländer and Zeiss in Germany had a better reputation and were imported in large numbers. The maximum aperture would have been around f16, smaller stops being obtained by sliding 'Waterhouse stops', circles cut in the centre of thin discs of brass, into a slot cut in the lens barrel.

Several such lenses of differing focal length would have been carried on an expedition although their size and their bulky brass mounts made them very heavy. The very least that Muybridge's whole plate outfit could have weighed would have been 120 pounds, and then only if he carried a dozen or so plates. On an expedition, of course, he would have taken a very much larger number and a considerable volume of chemicals; the final weight must have been terrific.

Having arrived at a location and set up his tent, he could take pictures within three minutes walking distance away (two minutes in hot weather). If he went further than this the collodion could dry before it was exposed and developed.

Some idea of the difficulties of using the wet collodion process out of doors has been given in the text, but perhaps it is also worth mentioning that Muybridge had to prepare his own chemicals, most of them every day, and probably had to select, cut and carefully clean the glass for the negatives himself; though ready-cut glass was available in Europe it is doubtful if any could be obtained in California.

The use of very large glass plates is nowadays confined to the 'process' (block-making) trade. Anyone who has carried a 20 × 24-inch loaded darkslide out of a darkroom and fitted it on to the back of a process camera knows it is quite an energetic undertaking, yet when Muybridge took his panoramic photograph of San Francisco in 1877 he did just that sixteen times in quick succession, making his

exposures and repositioning his camera in between.

Officially, the plates were exposed by means of a 'lenscap', a removable lid rather like the lid of a pillbox that fitted snugly over the front of the lens and prevented any light from entering. It was taken off with a twisting movement so as to shake the camera as little as possible, but the danger of vibration was always present. For this reason many photographers preferred to use a hat with a dark lining, holding it in front of the lens as the lenscap was removed, waiting a moment for any vibration to die down, whipping the hat away to start the exposure and reversing the procedure at the end. Muybridge's black Stetson may have been often used as a shutter.

The shortest exposure a really skilled operator could give by hand would have been about a fifth of a second, but with large cameras and small aperture lenses such brief exposures would have produced hopeless underexposure. In the 1850s and 1860s, however, some very small cameras had been fitted with lenses which had the huge apertures of f1.6 and even f1.1 and with these primitive shutters could be used, the power usually being supplied by elastic bands. Muybridge also used elastic in his early shutters which closely resembled the British Thornton-Pickard models which clamped on the front of the lens and were in common use up to around 1930.

Using wet collodion emulsion for landscape work presented one overwhelming difficulty – it was impossible to record white clouds against a blue sky and at the same time obtain detail in the foreground; not only was the difference in brightness between the sky and the ground too great for the high contrast plates but in addition the emulsion, being sensitive only to blue light, had difficulty in recording a difference between the sky and the clouds.

Attempts were made to solve the problem by handwork on the negative, white clouds being drawn on a blank sky with Indian ink and dark ones by painting them in with a reducer such as potassium cyanide. However, unless the artist was very skilled the result looked artificial and around 1860 the technique was invented of using two separate negatives, the one of the sky being given a short exposure and a full development to help the clouds to stand out and the one of the ground being fully exposed and then developed so as to retain the gradation. When the print was made the negative of the foreground was exposed first, the sky being held back (shaded) so that it would appear blank, then the separate negative of the clouds was printed into the area occupied by the empty sky.

Skilled technique was needed to avoid a white line or an overlap along the horizon line and to match the direction of the light falling on the clouds with that of the light on the foreground. Most landscape workers made a collection of sky negatives taken from different angles and at different times of day so that any landscape could be accurately matched. Muybridge soon became a master of this branch of photography and even today most of his landscapes look as if they were taken with modern panchromatic material and a filter.

When he started his motion analysis work at Pennsylvania the cameras he used were, by the standards of the time, very advanced affairs and look as though they were beautifully finished. We know the lenses were supplied by Dallmeyer and since at the time they also marketed cameras under their own name (though they may have been made by an outside firm) it is quite possible that they constructed the whole instrument. Unfortunately they cannot find any reference to ever having supplied Muybridge with anything in their records, but he may, of course, have purchased equipment through an agent.

It would be possible to match some of the slower of his sets of sequence pictures by using a modern motorized camera running at three frames per second, top speed for most of them. A four-second sequence could then be recorded on twelve frames of film, thus matching the twelve exposures made by Muybridge. When making negatives 24 × 36 mm in size (the same as those produced by a modern 35mm camera) he used 12.5cm f4 lenses set 3 inches apart, the last exposure being made from a point three feet to the right of the first. A modern photographer would not obtain exactly the same effect as Muybridge unless he could traverse his camera three feet during the sequence, no easy thing to do. He could obtain a closer match by moving further back and using a longer focus lens, perhaps 200mm, 'panning' the camera from a fixed position.

It is interesting to note that the dry plates that were used in the sequence camera and which revolutionized Muybridge's photography were made by an Englishman, John Carbutt, who had emigrated to the States. He later became the first person in the world to coat emulsion on sheets of celluloid and it is probable that he supplied the material for the duplicate sheet film negatives that Muybridge made from his originals to send to firms for making lantern slides and bulk prints. Many of these film negatives still exist.

Though Muybridge was an inventor, an original thinker, he had no hesitation in exploiting technical advances as they came on the market. Were he alive today he would no doubt be using short-duration strobe flash and motorized cameras, pestering the manufacturers for advance information about high-speed colour film and video tape, experimenting with holograms and turning out pictures which would be technically and artistically in advance of the rest. He would also probably have invented much new apparatus, specializing in the field of electronics. It is a mistake to think of him as an 'old-time photographer'; he was one of those extraordinary people who are dateless, who would have been an innovator in any age.

Appendix 3

Looking for Muybridge

I am always amused by the people who think that historical research is a dry and dusty business. Neither my wife Sheila nor I have led dull lives, but we have rarely found anything to match research for excitement and variety. Research combines the excitement of a treasure hunt with that of a detective story and, as we drove down to Kingston-on-Thames one summer morning, we had no idea what Muybridge material, if any, we would find. We knew that when he died he had left some of his possessions to the local museum, but it is only lately that his importance has been appreciated and much of it could have been dispersed over the last seventy years.

At the museum, we were welcomed by two charming ladies, Mrs Canham and Mrs Baker, who said that yes, there was a certain amount of stuff that might interest us. They led us into an office and, unlocking a huge steel door, tugged it open. Inside was a vault that to us was like Aladdin's cave. Boxes and boxes of slides, made and captioned by Muybridge, discs from his zoopraxiscope, huge volumes of *Animal Locomotion*, stereoscopic prints, panoramas – the problem was obviously going to be one of selection.

While we were considering the best way to tackle this huge undertaking, we went for a walk in the traffic-choked town to look for the place where he was born and for the Coronation Stone. We found the latter outside the Council Offices, but no one knew where The Bittoms, the street in which he was born, lay. A policeman said he was new around here and two housewives swore there was no such place. We finally found it ourselves, a few yards from where we had been asking, a narrow, winding road in the oldest part of the town. It had been almost entirely rebuilt in the last few years and I doubt if more than a couple of houses survived from Muybridge's day.

There was no plaque commemorating his birthplace. No one in The Bittoms had ever heard of him, though one helpful lady said there was a very good photographer in the High Street. Apart from the museum, as far as Kingston is concerned Muybridge never existed.

Back in the museum after lunch in a pleasant pub beside the river, we started work. All research is a compromise between the ideal and the possible; it is limited by the time and money available, in our case acutely so. Take the lantern slides, for instance. In order to obtain the best possible results we should have used a 5 × 4-inch technical camera fitted with a process lens, specially corrected to give very high resolution at short distances. As it happens, I have just such an instrument, a superb Gandolfi made for me by Mr Gandolfi himself out of rare Cuba mahogany, with lacquered brass fittings and 'beeswing leather' bellows. The lens, chosen for it by Zeiss Ikon, is a 15cm f8 Apo-Skopar; it is almost exactly the same type of equipment that Muybridge used himself. No camera would have given better reproduction of the tone and detail in the slides.

However, faced with making hundreds of copies, we realized the Gandolfi would be hopelessly slow. After every twelve pictures the slides would have to be reloaded in a changing bag and altering either the focus or the exposure would take too much time.

The ideal camera would probably have been the Rollei 66, a single-lens reflex that is ideal for close-ups, thanks to a built-in bellows extension, and which produces negatives $2\frac{1}{4}$ inches square, the same format as the slides. Its quick-loading magazines take 24 exposure lengths of 220 film and, fitted with a macro lens, it would have given almost as good a result as the Gandolfi in a fraction of the time. However, we did not use it simply because we could not afford to buy one – it costs as much as a small car.

So in the end we turned to our battered, reliable Contarex, a heavy, rugged 35mm single-lens reflex with a very accurate through-the-lens metering system. Its great advantage is that when copying one can raise the mirror without releasing the shutter, thus keeping vibration to a

minimum. For most of the work we used the standard f2 50mm Planar lens with the addition of a close-up supplementary lens, though occasionally we were lucky enough to be able to borrow a macro lens that would focus right down to a few inches.

In order to copy the slides the camera was fitted to a Reprophot stand, a four-legged affair that is usually employed for taking pictures of small objects. A sheet of glass was placed on the stage-plate and Muybridge's 3¼ inch square lantern slides were positioned on this. The Reprophot was placed on a large sheet of white paper and this was lit by two angle-poise lamps clamped to the edge of the table. The bulbs used were opal Photocresentas which are really intended for use in enlargers; they take 150 watts of current, have a very high light output and last for about a hundred hours.

Most of the light was concentrated on the white paper so that it would reflect up through the slide, but a certain amount was also allowed to fall on the upper surface so as to reproduce the caption and also to slightly lower the contrast. Both the position of the slide and the exposure were checked by looking through the viewfinder, half-stop variations being ignored but a correction being made for greater ones.

The film used was Ilford FP4, probably the best of the medium speed emulsions. A slower and finer grained film would in theory possibly have given higher quality, but it would have had less exposure latitude and would have needed more exposure. As it was I could give 1/30th of a second at f8; a slower shutter speed or a bigger aperture might not have given such a good result.

My wife and I are used to working as a team and we soon developed a routine whereby I took a slide out of the box, decided if it was important as quickly as possible and then, as I cleaned it, called out the caption to my wife. She wrote this down together with the frame number as I positioned it and made the exposure, raising the mirror, waiting a second or so and then releasing the shutter by means of

a cable release. As Sheila took the slide off the stage plate and stacked it, I was taking another slide from the box – it was quite surprising how fast the film ran through the camera; fortunately it can be reloaded without removing it from the stand.

To copy the plates from *Animal Locomotion* and other large items we used four lights instead of two in order to obtain more even illumination and fitted the camera to a 'table stand' which clamps to the edge of a bench and looks rather like the upright of an enlarger, the camera taking the place of the enlarger head. It has the supreme advantage of being readily portable.

The FP4 films were developed in Johnson's Definol, a high-definition developer that gives good edge sharpness and which increases the emulsion speed by about half a stop.

The two ladies in charge of the section let us turn their office into a miniature studio, completely disrupting their work. They carried material in and out of the strong room, went through their files for documents and tried to locate other Muybridge material in this country. They produced Muybridge's own scrapbook of press cuttings and various editions of his work. Unfortunately, many years ago some suspicious librarian had perforated the words 'Kingston-on-Thames Public Library' with a punch on every sheet of a collection of *Animal Locomotion* plates, thus neatly taking hundreds of pounds off their value.

A great deal of material had been lent to the Science Museum in London which has a fine photographic section, so after finishing at Kingston we took our camera and lights there to see what we could find. The curator, Dr Thomas, was extremely helpful and produced many boxes of slides, most of them relating to Central America. Once again, due to lack of time, we could only copy some of them.

Our next step was to follow up the many rumours we had heard about collections of negatives and prints. A lady in Paris was said to have a vast collection of huge

Muybridge landscapes, but we could not trace her. We knew that towards the end of his life Muybridge had sent hundreds of duplicate negatives, printed on large sheets of film, to Wilson's of Aberdeen so that slides could be made commercially. Though the University had a large number of negatives from this establishment, none of Muybridge's seemed to be amongst them. More negatives had apparently 'been sent to Europe for printing' but this was obviously too vague. There are a few stereoscopic prints in a collection in the West Country and the Royal Photographic Society has some plates from *Animal Locomotion*. Though I have a strong suspicion that a lot of Muybridge material remains to be discovered in this country, it would take a great deal of time to find it.

Not expecting any result, I wrote to the occupier of the house in Liverpool Road in which he died. The lady who replied not only sent me a most interesting and informative letter but included a photograph of the house as it had looked in Muybridge's day which is reproduced in this book.

Letters to the United States made me realize that though a large number of negatives and prints exists, they are hopelessly scattered across the whole continent. Here and there a university will have a few prints, a museum a number of negatives, but the best collection is probably in the George Eastman House.

Though museums cannot be expected to donate original material, I wonder if it would ever be possible to assemble prints and copies of all known Muybridge material at Kingston? It is the place where he was born and where he returned to die. He left his own personal record of his photographic career to the local museum and library. No other place, not even San Francisco, seems quite so appropriate. Perhaps one day historians, students of photography and everyone interested in Muybridge and his great work will make a pilgrimage to the town by the Thames.

Bibliography

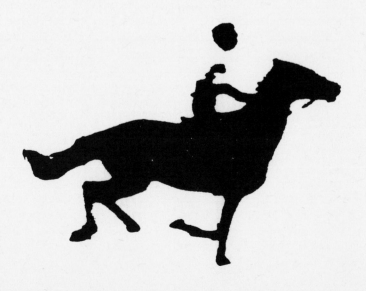

Books by Muybridge:

The Horse in Motion, Boston, 1882 (Text by J. D. B. Stillman)
Animal Locomotion, Philadelphia, 1887, 11 vols
Descriptive Zoopraxography, Philadelphia, 1893
Animals in Motion, London, 1899 (extracted from *Animal Locomotion*)
The Human Figure in Motion, London, 1901 (extracted from *Animal Locomotion*)
(The last two books were reprinted by the Dover Press, *Animals in Motion* in 1955, *The Human Figure in Motion* in 1957, the illustrations being made by re-photographing the collotype prints)

Books and articles on Muybridge:

Animal Locomotion, the Muybridge Work at the University of Pennsylvania, J. B. Lippincott Co., Philadelphia, 1888
'The Muybridge Moving Picture Experiments at the University of Pennsylvania', by George E. Nitzsche, *General Magazine and Historical Chronicle*, April 1929
Leland Stanford, by George T. Clark, Stanford University Press, 1931
Dictionary of National Biography Supplement 1901–11, Vol. 2, Oxford University Press, London, 1939
'The George E. Nitzsche Collection of Muybridge Relics', by Beaumont Newhall, *Medical Radiography and Photography*, Vol. 26, No. 1, 1950
History of the Life of Leland Stanford, Boibooks, Oakland, California, 1952
'Muybridge and the First Motion Picture', *Image*, Vol. 5, No. 1, 1956
'Muybridge and the First Motion Picture', by Beaumont Newhall, *U.S. Camera Annual*, 1957
'Eadweard Muybridge's Yosemite Valley Photographs, 1867–72', *California Historical Society Quarterly*, Vol. XL11, 1963
The Origins of the Motion Picture, by Dr D. B. Thomas, Stationery Office, 1964
The History of Photography, by Beaumont Newhall, Museum of Modern Art, New York, 1964
Photography's Great Inventors, American Museum of Photography, Philadelphia, 1965
'Eadweard Muybridge', by G. W. Hendricks, *Encyclopedia Britannica*, Vol. 15, 1966
'Eadweard Muybridge', by Thomas Andersen, *Film Culture*, No. 41, 1966

'The Lantern Slides of Eadweard Muybridge', by Dr D. B. Thomas, *British Journal of Photography Annual*, 1967

The History of Photography, by Helmut and Alison Gernsheim, Thames & Hudson, London, 1969

'Les Allures du Cheval (Muybridge's Contribution to the Motion Picture)', by Harlan Hamilton, *Film Comment*, 1969

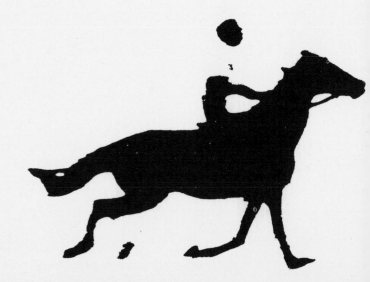

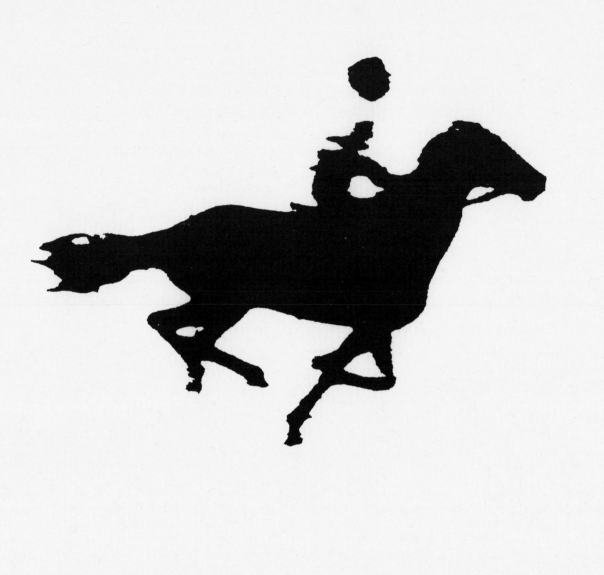